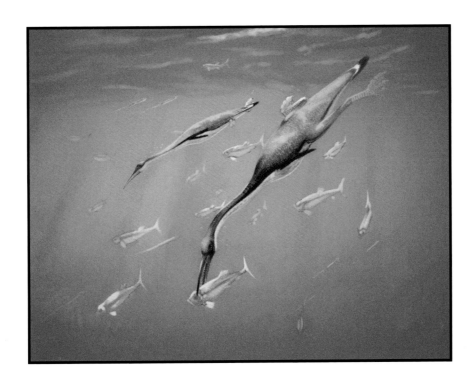

Dedicated to Dan Varner

About the Authors

John Conway
Artist and Author

John Conway is a palaeontological and fine artist, who's work has been used for National Geographic, Discovery Channel and the American Museum of Natural History, among others. His work has most recently appeared in Dinosaur Art: the World's Greatest Paleoart. John's interest in the methodology and culture of reconstructing of palaeontological subjects is the genesis of this book.

Website: johnconway.co
Twitter: @nyctopterus
Facebook: facebook.com/nyctopterus

C. M. Kosemen
Author and Artist

C. M. Kosemen holds a Media and Communications Masters' degree from Goldsmiths College, and has worked as an editor in Benetton Company's Colors magazine. He has had several exhibitons of his evolution-themed fine art at galleries and science festivals internationally. Kosemen's areas of specialization are speculative & real zoology, history and unusual things in general. His previous work includes *Snaiad*, a self-initiated web project about life on an alien planet.

Website: cmkosemen.com
Facebook: facebook.com/memo.kosemen

Dr. Darren Naish
Author

Darren Naish is a science writer, technical editor and palaeozoologist. Darren works mostly on theropod and sauropod dinosaurs, but also works on pterosaurs, marine reptiles, and other tetrapods. With colleagues, he named the dinosaurs *Eotyrannus*, *Mirischia* and *Xenoposeidon*. Darren has written several books, including Walking With Dinosaurs: The Evidence (co-authored with David M. Martill), Great Dinosaur Discoveries, and more recently Tetrapod Zoology Book One. His blog, Tetrapod Zoology, is widely considered the world's foremost zoology blog. When not writing about tetrapods, Darren can be found pursuing his interest in modern wildlife and conservation and resulting adventures in lizard-chasing, bird-watching and litter-collecting.

Website: blogs.scientificamerican.com/tetrapod-zoology/
Twitter: @TetZoo

Scott Hartman
Artist

Scott Hartman is a palaeontologist and illustrator who specialises in creating skeletal diagrams of dinosaurs and other animals to the highest degree of scientific accuracy. Scott's skeletal drawings form the basis of many other artist's work.

Website: skeletaldrawing.com
Twitter: @skeletaldrawing

Acknowledgements

We are thankful to our families and friends, whose love and support helped us through the making of this book. Several of our colleagues have provided feedback and discussion that helped shape our ideas. In particular Mike Taylor and Matt Wedel were generous with their encouragement and discussion.

We thank the late Dan Varner for discussion on the history of palaeoart; and Tim Isles, Luis Rey, Mark Witton and Steve White for thoughts on palaeobiology and palaeoart.

We thank John's wife, Jenny, for her support and proof-reading.

C. M. Kosemen would like to extend special thanks towards his parents, brother and sister for their unconditional love, support and friendship.

Irregular books

www.irregularbooks.co

All Yesterdays

Unique and Speculative Views of
Dinosaurs and Other Prehistoric Animals

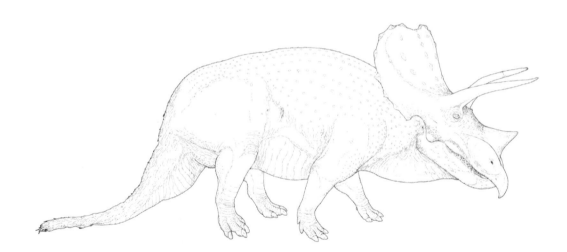

Introduction
by **Dr. Darren Naish**

A desire to imagine the long-extinct organisms of the past as living, moving animals has long inspired artists and scientists to clothe bones and other fossil tissues in muscles, skin, fur and feathers. In other words, to bring fossil animals 'back to life' in art. We need to be clear from the start that-while there are many things that we're surely getting right-there are many other things that have to be regarded as 'known unknowns', and even as 'unknown unknowns'. It is these areas of doubt and speculation that form the focus of this book, the first ever devoted entirely to the more speculative aspects of palaeoart.[1]

It is well known that the process of reconstructing a fossil animal involves a marriage of both 'hard' data as well as a degree of informed speculation. That 'hard' data involves such things as the lengths and widths of bones and other hard parts, and the positions of specific muscle groups present in living animals. While the creation of a bone-and-muscles-only reconstruction should be seen as the first step in the depiction of a fossil animal (and even as a presumably inescapable part of creating a reconstruction!), readers may be surprised to learn that many people who have reconstructed extinct animals have frequently done so without recourse to these vital steps.

We in fact know that this was true of some of the greatest and most influential palaeoartists of all time. The Czech master of ancient animals and landscapes Zdenîk Burian (1905-1981), for example, best-guessed the life appearance of dinosaurs and other vertebrates by fleshing out museum-mounted skeleton on paper without the use of measurements. Rudolph F. Zallinger's (1919-1995) animals – most famously depicted in the Zallinger mural at Yale's Peabody Museum of Natural History – were clearly done with only a superficial reference to the skeletons of the species concerned. The pieces of art generated by these individuals remain brilliant, beautiful and wonderful, but the techniques they used were damaging to the contention that the reconstruction of fossil animals involves science as much as it does art. Indeed, this concept is reflected in the paraphrased claim "There's more than one way to reconstruct a dinosaur", and in the general idea that dinosaurs and other fossil animals can only be reconstructed approximately, or with substantial doubt about the most basic issues remaining.

So we must note to begin with that reconstructing a fossil animal is not a speculative process that has many possible outcomes, but a rigorous and evidence-led one where informed artists produce a technically accurate musculoskeletal reconstruction for a given animal. The problem comes with the integument – the covering that involves the skin and all the things attached to it (scales, feathers, hairs and so on) – as we'll see.

Most people interested in palaeoart are aware of, and follow, the high-fidelity musculoskeletal reconstructions produced by researcher and artist Greg Paul. Many of Paul's hypotheses and arguments about archosaur[2] biology and evolution are the topic of argument and disagreement, but his explanations and illustrations of archosaur anatomy and the way he restores an animal's musculoskeletal system remain important. Paul's 1987 article 'The science and art of restoring the life appearance of dinosaurs and their relatives: a rigorous how-to guide'[3] remains a classic, and (while now very dated) it is probably the best and most useful introduction to the sort of information an artist would need (though read on).

Paul's initial forays into the accurate reconstruction of archosaur musculature were the result of communication with Robert Bakker; in turn, both Paul and

Bakker were inspired by Charles R. Knight's (1874-1953) discussions and depictions of animal anatomy. Knight is most famous for his many paintings of fossil dinosaurs and mammals, but he also illustrated living animals. His book—*Animal Drawing: Anatomy and Action for Artists*—should be obtained by anyone seriously interested in the subject.[4] Therein, we see Knight's excellent attention to anatomical detail (especially in mammals), his knowledge of musculature, and his pioneering use of silhouetted outlines to show the extent of soft tissues around the skeleton. Here is the origin of the 'anatomically rigorous' movement in palaeoart. However, Knight was a paradox. He understood well the link between osteology and musculature, yet he gave dinosaurs small, slender muscles that did not match their bones (dinosaurs actually seem to have had enormous, more bird-like muscles), and frequently drew dinosaurs freehand-style, again with what looks like poor attention to the proportions and nuances of the actual skeletons.

This paradox - this inherent contradiction - has remained throughout the history of palaeoart. Yes, there are efforts to be as rigorous as possible and to put in an enormous amount of unseen background research

Allosaurus (below) and *Diplodocus* (above) by Charles Knight. Note the slender, lizard-like thighs.

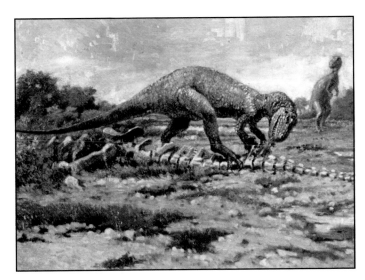

on the detailed anatomy of those fossil animals being reconstructed, but there are also quick and dirty ways of doing things where research is minimal. A large number of popular books about prehistoric animals use the work of individuals who do no research whatsoever, creating their digitally reconstructed animals simply by copying those depicted beforehand by other artists.

Paul's massive influence means that Mesozoic archosaurs-dinosaurs and pterosaurs especially-are nowadays frequently depicted in high-fidelity skeletal form before, or at the same time as, fleshed-out life reconstructions appear. Outside of archosaurs, little similar work is so obvious, bar the several anatomist-artists (including Jay Matternes and Adrie and Alfons Kennis) who have worked so hard to reconstruct the faces and bodies of fossil hominids. Mauricio Antón is now well known as an excellent and anatomically rigorous restorer of fossil mammals and other vertebrates:

his books and technical articles are as much about the detailed science of anatomical reconstruction as they are about evolution and palaeobiology.[5,6,7,8]

What needs to be made clear at this point, then, is that palaeoart of the sort discussed and depicted in this book is firmly grounded in a sceptical, rigorous, evidence-led effort to study and depict anatomy: the approach promoted by Paul, Antón and the like. Several other palaeoartists of the modern era- Jason Brougham, Mark Hallett, Scott Hartman, Bob Nicholls, Emily Willoughby and Mark Witton come to mind-are similarly part of the 'anatomically rigorous' movement. Others are not, and it shows.

It should be noted that there are some disagreements at the level of reconstructing skeletons and muscu- lature, and that improvements and tweaks are fre- quently being made. We mostly agree on the positions of muscles, for example, but the sizes of some of the muscles involved are variable in living animals and there is sometimes no reliable way of determining their size in fossil animals. This is well illustrated by Hutchinson et al.'s discussion of muscle mass and body size in *Tyrannosaurus rex*[9] where competing pos- sibilities made the same *T. rex* specimens look either svelte, muscular or ridiculously muscular. The fore- limb posture of bipedal dinosaurs has been exten- sively revised in recent years as workers have shown that palms faced inwards, not downwards,[10,11,12] and reassessment of dinosaurian tails have made it clear that Paul's dinosaurs are typically not bulky enough in the tail region.[13]

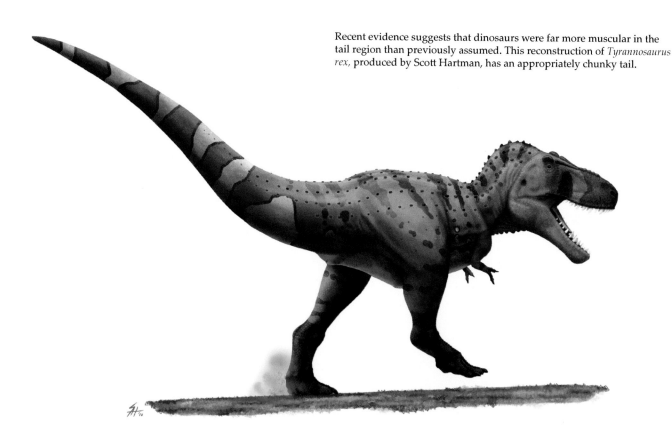

Recent evidence suggests that dinosaurs were far more muscular in the tail region than previously assumed. This reconstruction of *Tyrannosaurus rex,* produced by Scott Hartman, has an appropriately chunky tail.

The problem with integument

 The real complication in reconstructing fossil animals – the reason we're here, with a published book on the subject – is that there's all the soft stuff that goes on top of the musculoskeletal system. Integument is the great unknown for many fossil animals; its preservation is rare and infrequent, and even when it's preserved, it may be massively distorted or rearranged relative to its position in life. This is important, since the shape and size of the integument can radically change the appearance of the living animal relative to its underlying musculature and skeleton. The skeletons of modern birds – owls and parrots, for example – have long, slender neck skeletons, but overlying skin and thick feather coverings obscure these entirely. Extravagant head, wing and tail feathers present in some birds are not reflected in the underlying osteology either, and the manes, ruffs, thick furry coats and extensive amounts of skin linking the body with the limbs in many modern mammals are, similarly, not suggested at all by osteology.

If these observations extend across a wide diversity of living animals, would they have done so for extinct ones as well? We have little to go on, but what we know suggests that, yes, integumentary coverings may have effectively obscured much of the underlying anatomy that we've worked so hard to reconstruct. Notably, dinosaurs found with soft tissues (namely skin impressions and feathers) are flamboyant. Feathered dinosaurs are not only covered in feathers (with feathering extending from the middle of the snout all the way to the tip of the tail and even down to the ankles or toes), they have especially long, showy feathers growing off their arms and hands, the end parts of their tails, and even (in cases) from their thighs, shins and feet. Fossil mammals with body outlines and fur show a thick halo of tissues surrounding the skeleton, meaning that the skeleton was deeply submerged and effectively invisible in the live animal,

as is typically the case in modern species.

We are therefore presented with a huge diversity of 'known unknowns' and 'unknown unknowns' – the gate is open for all manner of bizarre possibilities as goes the life appearances of fossil animals.

It is these speculative possibilities that John Conway and C. M. Kosemen have explored in this book. Palaeontologists and palaeoartists talk about these sorts of ideas all the time-about the possibility that extinct animals were insanely flamboyant, that they had super-sized genitalia, or that they were insulated from the cool or even cold environments they sometimes inhabited by fat, thick skin, or fuzzy coats-but this is the first time ideas of this sort have been extensively discussed in print.

Feathers, body fat and soft tissues may have made real-life dinosaurs harder to identify than we think. Can you guess which dinosaur this is? Read on for the answer!

About the artists

John Conway and C. M. Kosemen are two of the most exciting of modern artists who are depicting extinct animals. Both combine remarkable attention to detail and technical accuracy with an understanding of art and art history and a desire to move forwards-to do something new, something innovative. Notably, both produce work in the digital realm and the internet is the true home of their many creations. A selection of John's outstanding works has recently been showcased in the stunning *Dinosaur Art* volume[14] and he is rapidly becoming well known as the face of the future. His dinosaurs and pterosaurs are not garish, flamboyantly pigmented, or shown in a stereotypical landscape of palm trees and volcanoes, but realistically muted and subtly hued, fitting into backgrounds that have been compared by some to impressionist paintings or Chinese watercolours. C. M. Kosemen is best known for his remarkable speculative and 'alternative' animals, some created as inhabitants of speculative future evolutionary scenarios (see his All Tomorrows project, available for free online, on human evolution) or of other planets (see his *Snaiad* project). His speculative 'smart dinosaur'- later labelled *Avisapiens saurotheos* and created as an antidote to the green, scaly humanoids imagined by some palaeontologists-became an internet sensation.

 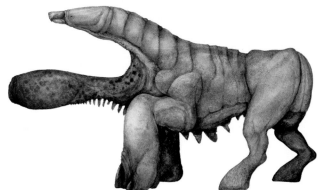

Above, Two aliens, a predatory *Kahydron* and an armored, herbivorous *Allotaur*, from C. M. Kosemen's *Snaiad*. Below, the intelligent *Avisapiens*, also by C. M. Kosemen.

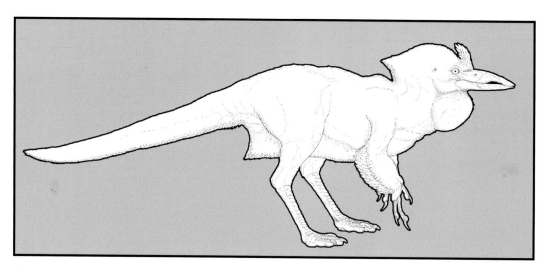

To the future!

This book goes beyond some speculative possibilities about the life of the past; it also indulges in a fun thought-experiment about a hypothetical future. We humans have struggled to interpret the often scrappy remains of fossil reptiles and other animals – it has taken us decades, and a huge amount of luck and careful detective work, to understand the true life appearance of small, predatory dinosaurs, giant marine reptiles like plesiosaurs and mosasaurs, and other such creatures. Think of the many mistakes we made along the way: plesiosaurs with the insanely long neck misinterpreted as the tail, *Iguanodon* imagined as a rhino-shaped, reptilian 'pachyderm', bird-like predatory dinosaurs depicted more as big lizards or even as giant turtles (this happened with *Therizinosaurus*), and so on.

Now consider what might happen were hypothetical non-human scientists confronted with the remains of modern animals. If we imagine that these curious and scientifically advanced creatures tried to reconstruct modern birds, mammals and other animals, would they end up with reconstructions that approach reality? It's an interesting thought experiment. Indeed, I tried it myself some years ago, wondering just how modern cetaceans might be reconstructed if hypothetical future scientists looked at them without knowing of mammalian soft tissues. Many cetaceans have bizarre tall spines growing upwards from their vertebrae; such distinctive structures as the fatty melon on the top of the head and tail flukes are wholly missing in fossils, and there's no clear evidence for a thick covering of blubber. Here, then, are my 1997 efforts to imagine a bottlenose dolphin and Dall's porpoise, pretending all the while that I'm a non-human, non-mammalian palaeontologist from the future…

However, certain characteristics known as **osteological correlates**[15] can be used, with some reliability, to deduce soft tissue or integument from skeletal details. Trunked mammals like elephants have unusual bony recesses and other structures around their enlarged bony nasal openings that help anchor the musculature associated with a proboscis, and also possess a specially enlarged braincase opening for one of the nerves that supplies the trunk. The melons and spermaceti organs of toothed whales are housed in concave basins on the skull roof, and the presence of horizontal tail flukes in cetaceans are hinted at by the shapes of the vertebrae at the tail's end. However, these are things that we've discovered with the benefit of hindsight, or have investigated specifically because we knew about the soft tissue structures in the first place. If we truly imagine that modern animals are represented in a future fossil record by imperfect remains, just like ancient fossils in the real, modern-day world, things could indeed be very different.

Science and speculation are happy bedfellows, so long as we remain grounded in our speculations, and so long as we state the core evidence we have in the first place. When it comes to the reconstruction of fossil animals, there will always be a great many aspects of anatomy, behaviour and lifestyle that will remain unknown, and for which a modicum of reasonable speculation will be allowed, and even necessary. Enjoy the ride.

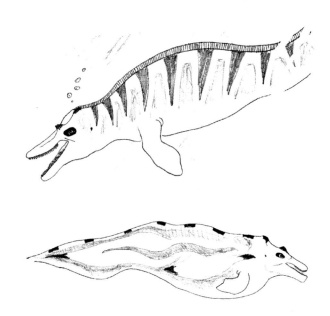

Notes and References

1 A minor note on terminology. Some people argue that the term palaeoart (or 'paleoart' if you're American) should best be applied to art produced during prehistoric times, and that artwork depicting prehistoric times and prehistoric organisms therefore needs a new name. However, the only word yet on the cards-palaeontography-has yet to catch on.

2 Archosaurs are the 'ruling reptiles': dinosaurs, crocodiles and all of their relatives.

3 Paul, G. S. 1987. The science and art of restoring the life appearance of dinosaurs and their relatives-a rigorous how-to guide. *In Czerkas, S. J. & Olson, E. C. (eds) Dinosaurs Past and Present Vol. II.* Natural History Museum of Los Angeles County/University of Washington Press (Seattle and London), pp. 4-49.

4 Knight, C. R. 1959. *Animal Drawing: Anatomy and Action for Artists. Dover Publictions* (New York), pp. 119.

5 Agustí, J. & Antón, M. 2002. *Mammoths, Sabertooths, and Hominids: 65 Million Years of Mammalian Evolution in Europe.* Columbia University Press (New York), pp. 313.

6 Antón, M. 2003. Appendix: notes on the reconstructions of fossil vertebrates from Lothagam. In Leakey, M. G. & Harris, J. M. (eds) Lothagam: the *Dawn of Humanity in Eastern Africa.* Columbia University Press (New York), pp. 661-665. CF1

7 Antón, M. & Galobart, À. 1999. Neck function and predatory behavior in the scimitar toothed cat *Homotherium latidens* (Owen). *Journal of Vertebrate Paleontology* 19, 771-784.

8 Antón, M., García-Perea, R. & Turner, A. 1998. Reconstructed facial appearance of the sabretoothed felid *Smilodon. Zoological Journal of the Linnean Society* 124, 369-386.

9 Hutchinson, J. R., Bates, K. T., Molnar, J., Allen, V. & Makovicky, P. J. 2011. A computational analysis of limb and body dimensions in *Tyrannosaurus rex* with implications for locomotion, ontogeny, and growth. *PLoS ONE* 6(10): e26037. doi:10.1371/journal.pone.0026037

10 Gishlick, A. D. 2001. The function of the manus and forelimb of *Deinonychus antirrhopus* and its importance for the origin of avian flight. In Gauthier, J. & Gall, L. F. (eds) N*ew prespectives on the origin and early evolution of birds: proceedings of the international symposium in honor of John H. Ostrom.* Peabody Museum of Natural History, Yale University (New Haven), pp. 301-318.

11 Senter, P. & Robins, J. H. 2005. Range of motion in the forelimb of the theropod dinosaur Acrocanthosaurus atokensis, and implications for predatory behaviour. *Journal of Zoology* 266, 307-318.

12 Bonnan, M. F. & Senter, P. 2007. Were the basal sauropodomorph dinosaurs *Plateosaurus* and *Massospondylus* habitual quadrupeds. Special Papers in Palaeontology 77, 139-155.

13 Persons, W. S. & Currie, P. J. 2011. The tail of *Tyrannosaurus* : reassessing the size and locomotive importance of the M. caudofemoralis in non-avian theropods. *The Anatomical Record* 294, 119-131.

14 White, S. 2012. *Dinosaur Art: the World's Greatest Paleoart.* Titan Books (London), pp. 188.

15 That is, distinctive bits of bony anatomy that reliable reveal the presence of some soft tissue structure. A circular bony socket on the side or front of the skull, connected to the brain by nerve openings, for example, is a good osteological correlate for an eyeball.

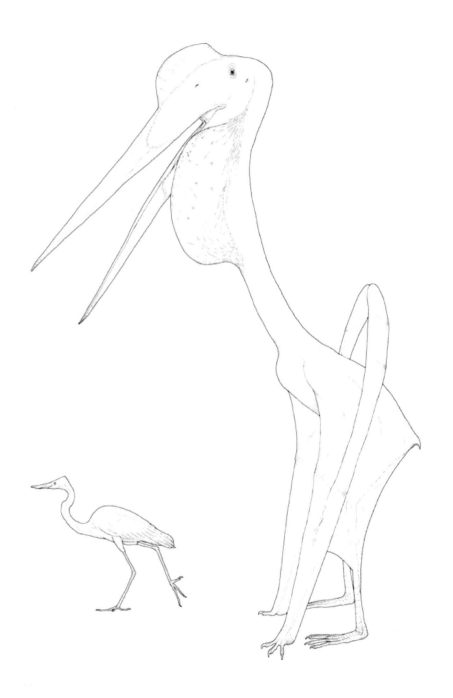

All Yesterdays

What images come to mind when you hear the word "dinosaur"? Perhaps you picture enormous lumbering animals, lurking in the swamps of old; or maybe you imagine lithe predatory dinosaurs sprinting on lean muscular legs, perfect killing machines with mouths agape in perpetual screams. In recent years, these views have become opposing stereotypes, putting prehistoric animals in straightjackets of appearance and behaviour.

We wanted a way out - a way that would show dinosaurs as plausible, real animals that engage in complicated behaviours such as playing, curiosity and mating displays.

While it is reasonable to think that that the purpose of palaeontological art is to mainly display the latest knowledge about extinct animals, it can also serve as an arena to propose new hypotheses, rather than repetitively drawing proven theories. In the history of palaeontology, out-of-the-norm images have been crucial in popularizing new notions about the appearance and behavior of extinct animals.

While we are well aware that some of our reconstructions will probably be falsified, some may actually "hit the spot," or may even look modest when compared to new fossil discoveries. Only time will tell!

Carnotaurus

and other arm-wiggling abelisaurs

Perhaps owing to its "bull-like" horns, *Carnotaurus* has become one of the more popular predatory dinosaurs in public knowledge. A member of an unique lineage of mostly Southern Hemisphere predators known as **abelisaurids**, Carnotaurus had a short, deep skull, heavy-set limb bones and very short arms. Although *Carnotaurus* is known from reasonably complete remains, almost every feature of this animal's body is surrounded by a cloud of theories and debates. Visible yet frustratingly unknown, *Carnotaurus* is the perfect palaeontological enigma.

This reconstruction was conceived as we tackled of the more interesting anatomical details of *Carnotaurus*, namely, its comically-stunted hands. Although short dinosaur arms immediately remind one of *Tyrannosaurus, Carnotaurus* and other abelisaurids independently evolved a wholly different and even stranger set of arms, which still bore a full set of four fingers. The upper arm bones (or humeri) were long and straight while the lower arm bones were comically short. The head of the humerus was rounded and ball-like, a feature indicating that substantial motion was possible at the shoulder joint. It seems that *Carnotaurus* and kin could stick their arms out sideways in a manner completely unlike that of other large predatory dinosaurs.

What was the reason for this arrangement, and why was it maintained across abelisaurids rather than fading away? Perhaps the baby arms still had a function, albeit a social one. Palaeontolo-gists Phil Senter and J. M. Parrish suggested exactly this, proposing that *Carnotaurus* and its relatives most likely waved their arms and hands around when displaying to mates or rivals.[1] We have to note that we came up this idea independently of that study, and only learnt about its existence after creating the artwork you see here. It's difficult to think of a better role for such weird structures.

Here, you can see a bull *Carnotaurus* and a related form, *Majungasaurus*, in full display, flashing brightly-colored arms and facial wattles to potential mates, or rivals. Seen head on, *Carnotaurus* looks more like a science-fiction creature rather than a dinosaur, yet it must be remembered that the sideways-facing depictions we are accustomed to are artifacts of scientific illustration, laid out for maximum visibility and clarity. Real-life animals would not have been so direct.

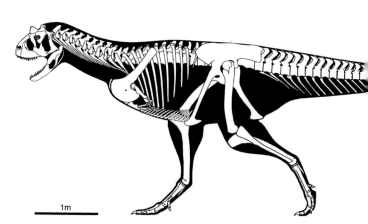

1m

1 Senter, P. and J. M. Parrish. 2006. Forelimb function in the theropod dinosaur Carnotaurus sastrei, and its behavioral implications. PaleoBios 26(3):7-17.

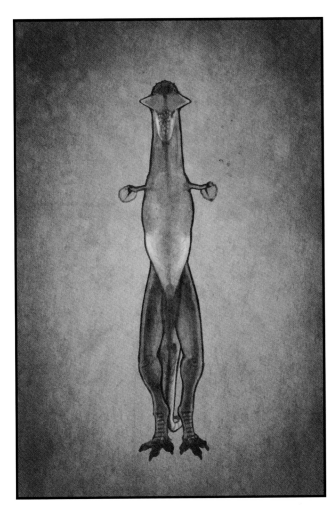

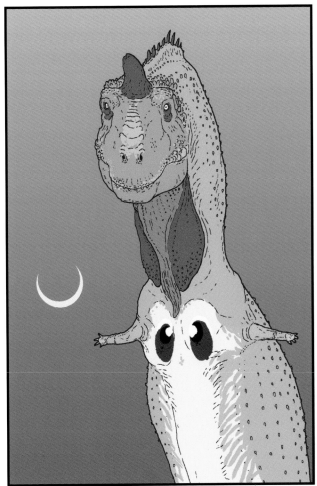

Elasmosaurus
in a neck-swinging contest

Even if one day, we had access to perfectly preserved fossils, a vital aspect of animal life would still elude our grasp. Behaviour is almost entirely lost in the fossil record. Imagine the richness, and the strange wonder of animal life today. The eerie, ululating songs of whales, the elaborate middens of bowerbirds and the surreal spectacle of a peacock's display could never be deduced from inanimate remains.

Likewise, some of the most spectacular sights of the past will never be seen, or even guessed at. In this painting, we have tried to imagine one such behavioral phenomenon with **elasmosaurs**, long necked marine reptiles that lived during the Cretaceous period. Although they feature in many books about dinosaurs, elasmosaurs were not members of the dinosaur family. Instead, they hailed from a distinct lineage of marine reptiles known as plesiosaurs.

This particular group of male elasmosaurs are out in the open sea, trying to see who is the toughest by lunging up from the depths and waving their necks. While old depictions mistakenly portrayed elasmosaurs as holding their necks swan-like above the water surface, these animals actually had very dense bones and heavy necks that could probably not be lifted out of the water when the animal was in its standard, horizontal pose.[1] Accordingly, the stunt seen here would have been very difficult and energy-demanding, and could not be sustained for more than a few seconds. What better way is there for males to prove their strength than through rigorous, energy-intensive bouts of a ridiculously pointless activities? No record of such behaviour could possibly exist - it is wholly and unashamedly speculative - and yet things equally spectacular must have happened throughout the history of life.

1 Everhart, M. J. 2005. Oceans of Kansas - A Natural History of the Western Interior Sea. Indiana University Press, 320 pp.

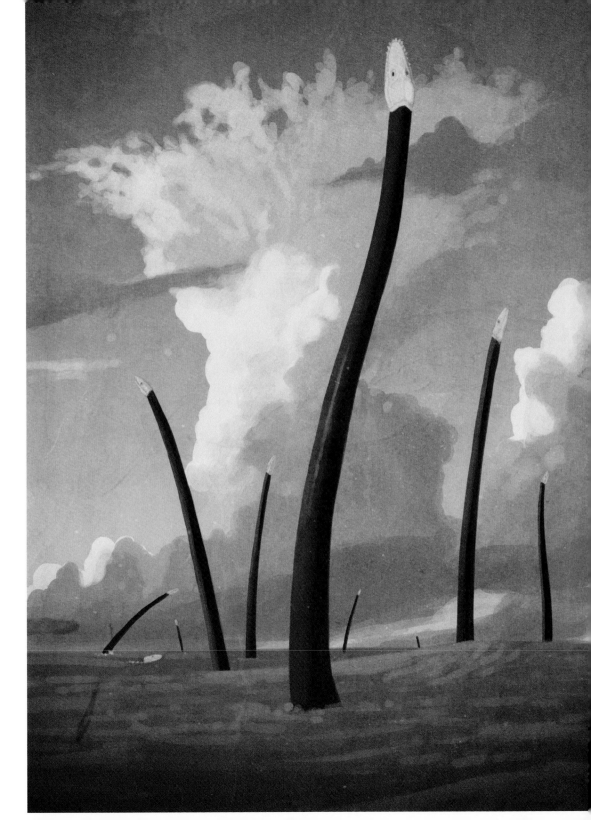

Anurognathus
falls victim to a giant centipede

Pterosaurs are everybody's favorite prehistoric flyers. *Anurognathus* was a member of an extraordinary group of pterosaurs known as **anurognathids**. Members of this group were characterized by extremely small size, short, broad wings and wide, frog-like mouths. They are further unusual in possessing short tails, an independently-evolved feature elsewhere seen only in the larger, more "advanced" pterosaurs called pterodactyloids. Judging from their wing and skull shape, anurognathids are thought to have lived like today's insect-eating bats.

Small-bodied animals like bats and anurognathids are rarely preserved in the fossil record. Although only several anurognathid specimens are known to science, there may have been hundreds, even thousands, of different anurognathid species living in the lost forests, caves and islands of the past. These animals must have lived in a world of danger, where they were vulnerable to predation, not just from dinosaurs, birds and other pterosaurs, but also from smaller animals like mammals, insects, spiders and centipedes.

Our illustration depicts the death of an anurognathid at the formidable jaws of a large scolopendrid centipede. Centipedes have a poor fossil record, but scolopendrids are known from the Cretaceous: in fact, some Cretaceous centipedes are virtually indistinguishable from modern ones. It is wholly plausible that large scolopendrids were snatching small, flying animals during Mesozoic times, just as they do today.[1]

1 Molinari, J., Gutiérrez, E. E., de Ascenção, A. A., Nassar, J. M., Arends, A. & Márquez, R. J. 2005. Predation by giant centipedes, Scolopendra gigantea, on three species of bats in a Venezuelan cave. Caribbean Journal of Science 41, 340–346.

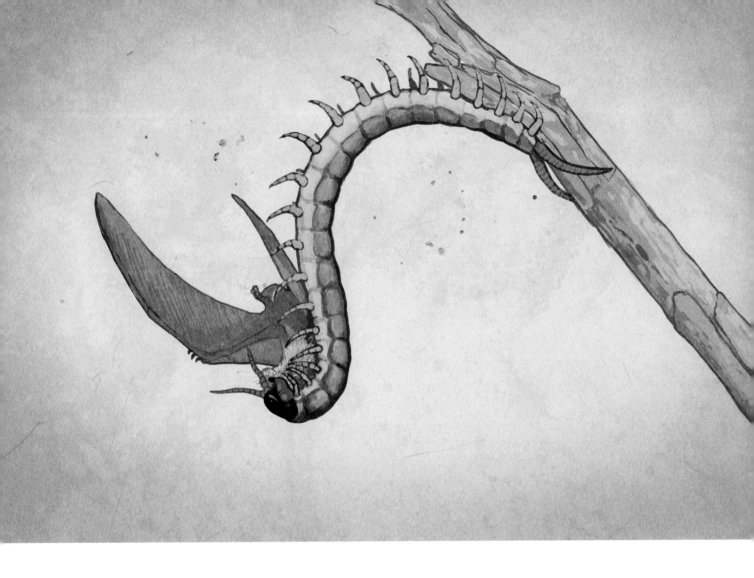

Allosaurus fragilis
and Camptosaurus dispar

Palaeontology aims to obtain a clear, natural view of the past, but gratuitous acts of predation and vicious monsters are an undeniable factor in attracting people to the study of dinosaurs. The tradition of palaeoart is full of such epic battles, almost as canonical as the clash of heroes in classical mythology. No children's book is complete without scenes of *Tyrannosaurus* attacking *Triceratops*, matched in miniature by a *Velociraptor* locked in mortal combat with a *Protoceratops*, and so on.

While predation is indeed a vital (and violent) fact of nature, not all predator-prey encounters end in cinematic bloody struggles. More often than not, hunters give up on chasing their quarry. Predators regularly ignore animals that won't be worth the energy to pursue them, and herbivores may cautiously approach meat-eaters while seeking common resources such as water. Curiosity, fear, intimidation and exhaustion make predator-prey relationships far more complicated than we typically picture them to be.

In this scene, set in the Late Jurassic, a herbivorous *Camptosaurus* is seen approaching a resting *Allosaurus* in what appears to be a curious social gesture. While *Allosaurus* was certainly a regular predator of *Camptosaurus*, this encounter seems to be a peaceful exception to the norm. In today's ecosystems, predatory big cats and herbivores have also been observed interacting in similarly non-violent ways.

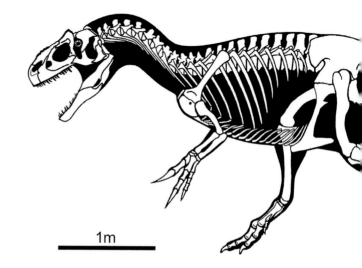

1m

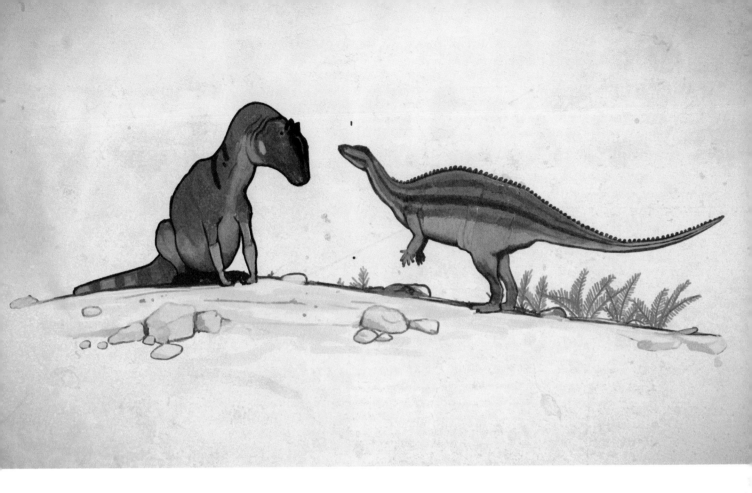

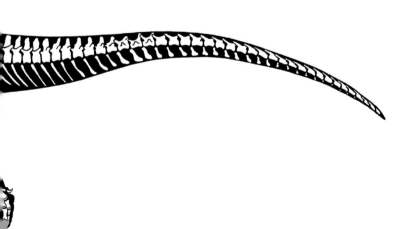

Tenontosaurus
takes a stroll

Like mythical figures cast into tragic roles, some dinosaurs suffer terrible fates in palaeoart, experiencing the same deaths over and over again. *Tenontosaurus* - a horse-sized member of the same group as *Iguanodon* that lived in North America during the Early Cretaceous - was one such dinosaur. Because its remains were found in association with the meat-eating *Deinonychus*, scientists have argued that *Tenontosaurus* was a frequent prey of the vicious, bird-like predators (Maxwell & Ostrom 1995).[1]

While this assumption is possibly correct, it has become a cliché; in fact, it is almost impossible to find a reconstruction of *Tenontosaurus* where it isn't being viciously torn apart by a pack of *Deinonychus*. Relegated to the role of "stock fodder," many unique features of *Tenontosaurus*, such as its unusually long tail and interesting position within the iguanodontian family tree, have been mostly overlooked by the general audience.

In real-world ecosystems, predators are far less common than their quarry. It is thus absolutely likely that *Tenontosaurus* spent most of its time feeding and resting, not fending off *Deinonychus* attacks. To illustrate this point, we depict *Tenontosaurus* happily walking along, without a single *Deinonychus* in sight. This surely happened on a regular basis.

1 Maxwell, W. D. & Ostrom, J. H. 1995. Taphonomy and paleobiological implications of Tenontosaurus-Deinonychus associations. Journal of Vertebrate Paleontology 15, 707-712.

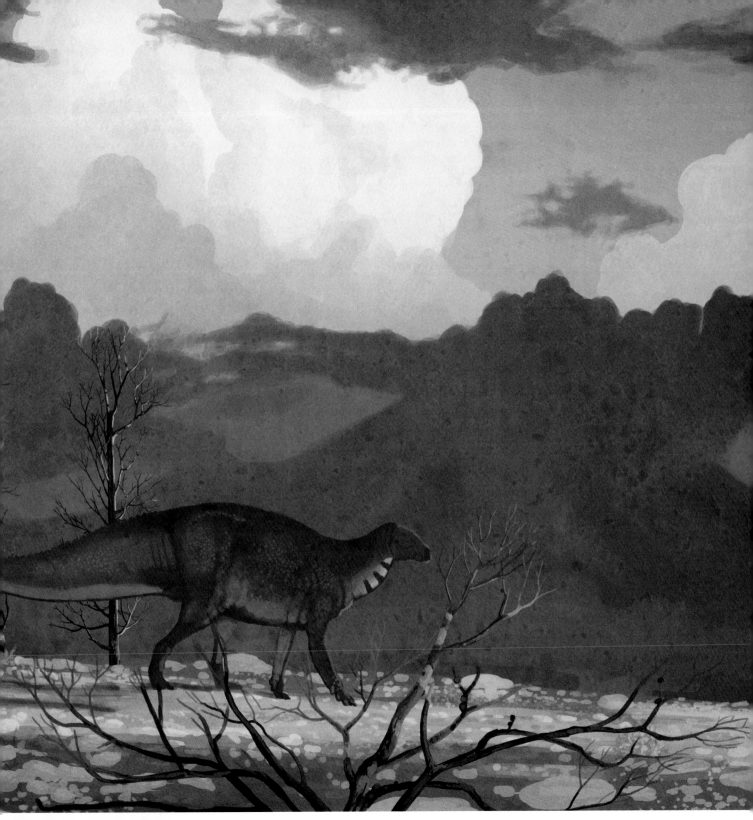

Hypsilophodon
eats a millipede

Much like wildlife art, prehistoric art has unconsciously cast roles for animals and their behaviour. Predators are always on the hunt, giants are always seen in majestic repose, while small herbivores, depicted as meek and innocent, are either shown grazing or in hurried flight from some terrible hunter.

With small, herbivorous dinosaurs, this type-casting has a risk of falling short of reality. To begin with, herbivorous animals are not "innocent" of occasional predatory acts. Modern herbivores eat, or will at least try to eat, a wide variety of things. Deer and sheep have been observed chewing the heads and feet off seabirds[1], squirrels often eat bird hatchlings for an extra helping of protein, and it turns out that even cattle will eat bird's eggs and nestlings if they find them.[2] Moreover, one can only draw general connections between anatomy and dietary adaptations in fossil animals. There is no doubt many of these are correct assumptions, but then again, we may be overlooking some fascinating possibilities.

Here, we see *Hypsilophodon*, generally known as the ultimate small dinosaurian herbivore. This particular *Hypsilophodon* is unaware of future speculations on its remains, and is happily supplementing its plant diet with small animals.

However, this snack will give it a nasty surprise - millipedes often cover their bodies with foul-tasting chemicals.

1 Furness, R. W. 1988. Predation on ground-nesting seabirds by island populations of red deer Cervus elaphus and sheep Ovis. Journal of Zoology 216, 565-573.
2 Nack, J. L. & Ribic, C. A. 2005. Apparent predation by cattle at grassland bird nests. The Wilson Bulletin 117, 56-62.

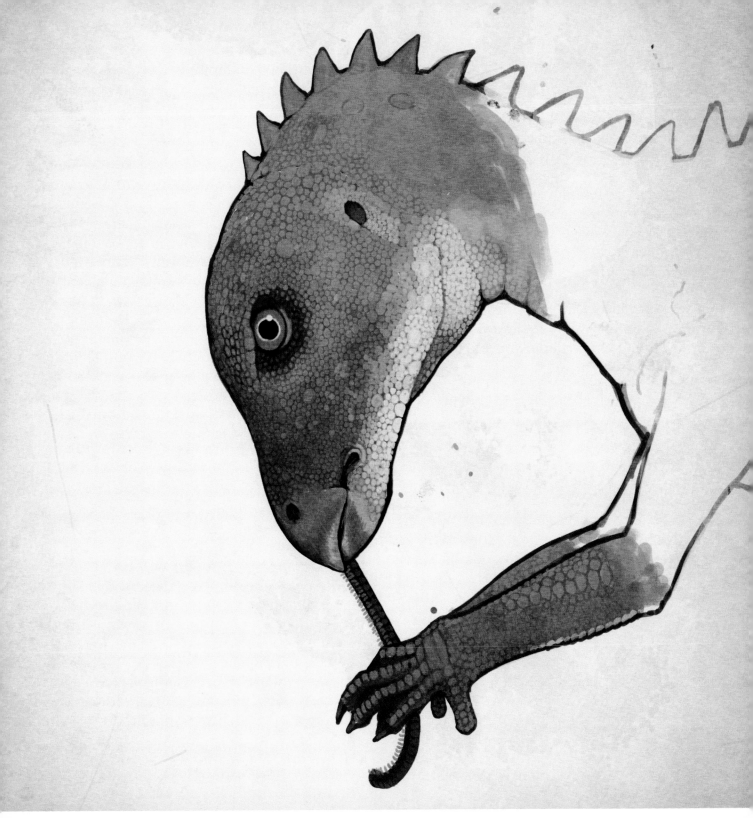

Sexual Oddities
Stegosaurus and Citipati

Reproduction is one of the most important, if not the most important driving force in evolution. Pressure for sexual displays have produced the peacock's dazzling tail feathers, the musical songs of birds, and the various horns, crests and frills adorning animals of every size and shape. Socio-sexual display behaviours may even have contributed to the evolution of language and human intelligence.

With reproductive acts playing such a vital role in the evolution of life, it is surprising that the issue has not received more attention in palaeo-art. If we assume that the sex habits of Mesozoic dinosaurs were similar to those of their modern descendants (the birds), then a dazzling, even bizarre, range of possibilities reveal themselves.

Among modern birds, ducks are notorious for the prevalence of aggressive mobbing and gang-raping in their sexual habits. In some duck lineages, female vaginal canals and male penises have entered a bizarre sexual "arms race,"[1] one of the results being that the males of some species have penises that can sometimes be as long as the head, neck and body combined [2]

We have imagined a similar scenario in this particular reconstruction of *Citipati*, an oviraptorosaurian maniraptoran theropod from the Late Cretaceous. This *Citipati* has expired after a particularly rough season of mating, but at least its genes have been safely passed on to the next generation.

Another possibility we have considered is interspecies mating. When sexually aroused, excited or unable to find available members of their own kind, animals mate with members of other species with surprising regularity. Incidents of this sort are probably more common than generally realised, and there is evidence from the modern world that they occur increasingly during times of environmental stress or as populations become reduced or brought together due to changing conditions. When the species concerned are closely related, hybrid babies can be the result: numerous such cases are known from the modern world. However, matings between distantly-related species also occur in the wild. These seem to serve no function other than to relieve the frustration or boredom of at least one of the participants. As unsettling as they may seem, such acts may even be considered to be part of the animals' play behavior. In one especially celebrated recent case, an apparently frustrated Antarctic fur seal (*Arctocephalus gazella*) copulated with a King penguin (*Aptenodytes patagonicu.s*) [3] It is well known that modern elephants are prone to a sort of seasonal sexual madness when they go through a phase of heightened sexual aggression termed musth. While in musth, elephants have been observed trying to forcefully mate with members of different species, such as rhinos.

1 Brennan, P. L. R., Prum, R. O., McCracken, K. G., Sorenson, M. D., Wilson, R. E. & Birkhead, T. R. 2007. Coevolution of male and female genital morphology in waterfowl. PLoS ONE 2 (5): e418. doi:10.1371/journal.pone.0000418
2 McCracken, K. G. 2000. The 20-cm spiny penis of the Argentine lake duck (Oxyura vittata). The Auk 820-825.
 McCracken, K. G., Wilson, R. E., McCracken, P. J. & Johnson, K. P. 2001. Are ducks impressed by drakes' display? Nature 413, 128.

3 de Bruyn, P. J. N., Tosh, C. A. & Bester, M. N. 2008. Sexual harassment of a king penguin by an Antarctic fur seal. Journal of Ethology 26, 295–297.

We combined ideas about interspecies mating events with both the possibility of oversized sexual organs and of a seasonal 'sexual madness'. The result: a bull *Stegosaurus* trying to mount an innocent *Haplocanthosaurus*. (overleaf,) In order to mate with females bearing a phalanx of dangerous spines and armored plates, we imagined male stegosaurs to have developed some of the largest and most frighteningly dextrous penises of the dinosaur world.

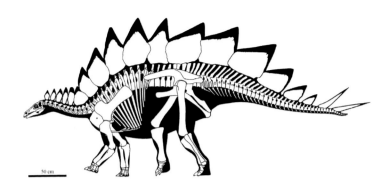

50 cm

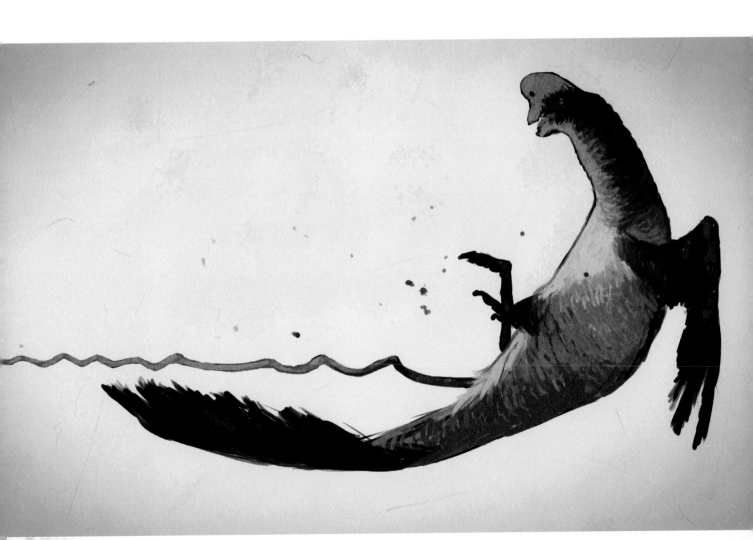

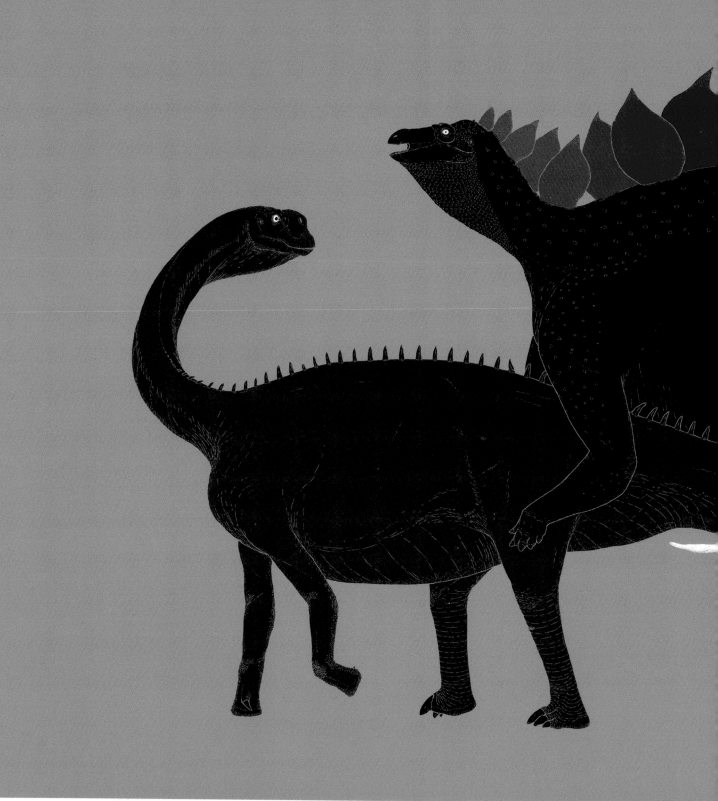

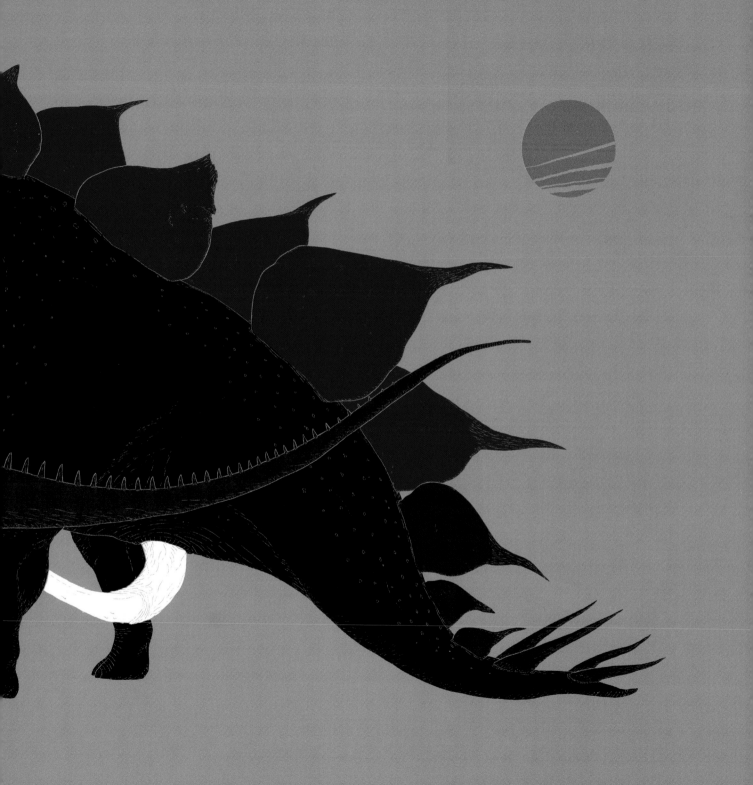

Camarasaurus
playing in mud

Of all the kinds of behaviour that animals can engage in, it's probably **play** that been depicted the most rarely. Plenty of pieces of art show dinosaurs running, jumping, attacking or defending themselves from other dinosaurs, and some even show dinosaurs mating and defecating, but almost none show them playing. The celebrated artist Luis Rey might be unique, then, in having published a scene where dromaeosaurids and troodontids are shown playfully sliding down a snowy slope in a Late Cretaceous winter,[1] inspired by behaviour seen in living magpies and crows. Other than Rey's work, no artist seems to have thought of dinosaurs in play. This lack of interest is no doubt maintained through the idea that only "smart" animals such as birds and mammals engage in play behaviour.

Interestingly enough, it is now known that play behaviour is not limited to birds and mammals. Monitor lizards, turtles, crocodiles and even fish and cephalopods have been reported to engage in behaviours that do not seem to serve any other purpose than simply having fun.[2][3] If all these animals could play, we are certain that Mesozoic dinosaurs could, too. Here a sub-adult *Camarasaurus* is shown enjoying the soothing feeling and antiparasitic properties of a good roll in the mud.

Camarasaurus was a large sauropod dinosaur from the Late Jurassic of North America. Well-known for its boxy skull and stout proportions, it is considered by some experts to be among the ugliest of all sauropods.

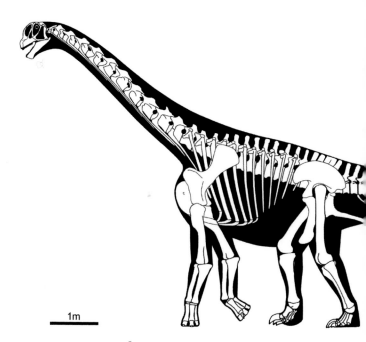

1 Rey, L. V. 2001. Extreme Dinosaurs. Chronicle Books (San Francisco), pp. 62.
2 Burghardt, G. 2005. The Genesis of Animal Play: Testing the Limits. MIT Press, Cambridge, MA.
3 Naish, D. 2009. Dinosaurs come out to play (so do turtles, and crocodilians, and Komodo dragons). Tetrapod Zoology ver 2 http://tinyurl.com/9fw5odb

1m

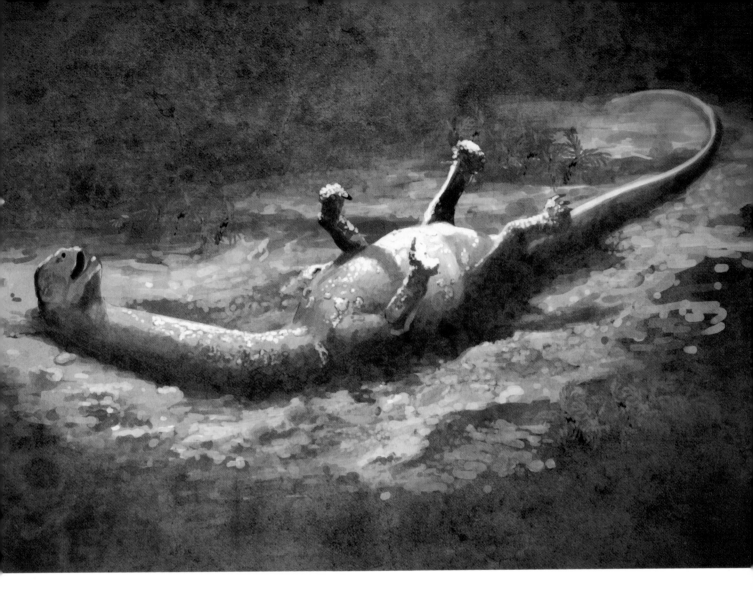

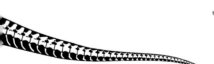

Sleepy Stan
Tyrannosaurus rex

If popular depictions are to be believed, *Tyrannosaurus* spent most of its life charging at hapless victims while roaring at the top of its lungs. This image, immortalized by movie and comic book depictions, is false on both fronts. To begin with, predators almost never roar or scream while attacking. Stealth is vital in nature. A hunter like *Tyrannosaurus* must have waited silently, and kept as quiet as possible as it hunted. Even the slightest noise could have scared its prey away. The only things its victims would have heard would be the crashing of the vegetation as the giant predator charged towards them.

Secondly, as we saw before with *Allosaurus*, hunts take up only a minor part of a predator's lifetime. Most hunting animals spend long days resting, either in order to conserve energy, or while digesting the food acquired from a fresh kill. Like most warm-blooded modern predators, the fearsome *T. rex* may have spent most of its time asleep.

Here, we portrayed a large specimen of *Tyrannosaurus* with an unusually large head, also known as "Stan." In this picture, Stan has just finished a big meal and is sleeping soundly as he digests his fill. A *Tyrannosaurus* like Stan was probably capable of eating tonnes of flesh in a single hunt, and would have eaten relatively infrequently. It could have taken Stan several days to sleep off the exhaustion and torpor of a meal.

The sleeping poses of tyrannosaurs have also been an interesting area of speculation. Resting poses have been depicted for tyrannosaurs before: Lawrence Lambe imagined tyrannosaurs lying flat on their bellies, partly due to their boot-shaped pubic bones.[1] It was also thought that giant animals could not lie on their sides due to their excessive weight. As a result, an artistic meme was born, where tyrannosaurs were never shown sleeping on their sides. As demonstrated by elephants, however, even tyrannosaur-sized animals can and do recline on their sides and sleep deeply.[2]

How, when and where other big dinosaurs slept remains a fascinating area of speculation.

1 Lambe, L. M. 1917. The Cretaceous theropodous dinosaur Gorgosaurus. Memoirs of the Geological Society of Canada 100, 1-84.
2 Naish, D. 2008. Sleep behaviour and sleep postures. Tetrapod Zoology ver 2 http://tinyurl.com/95bz7fc

1 m

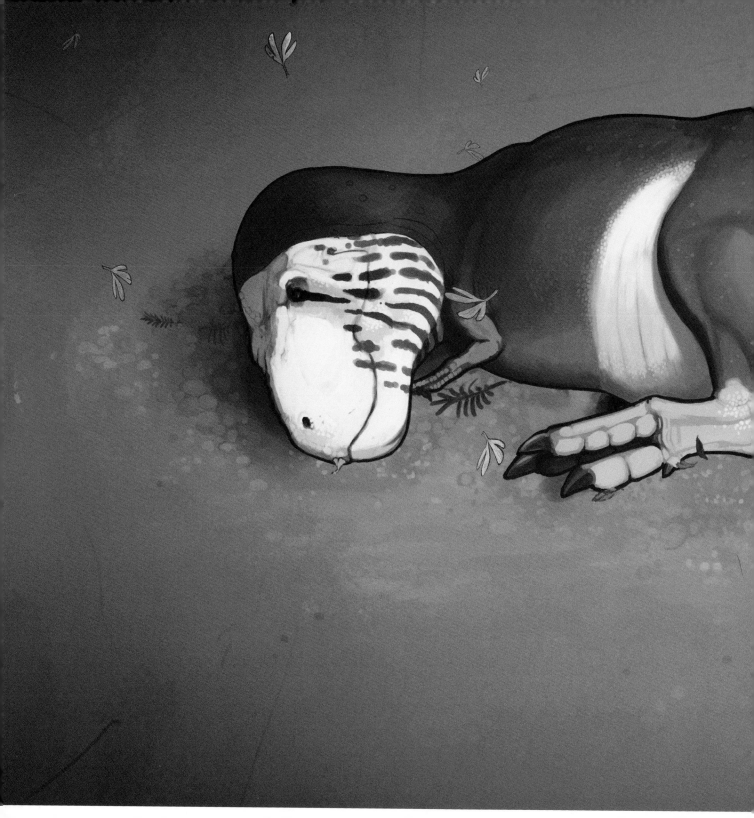

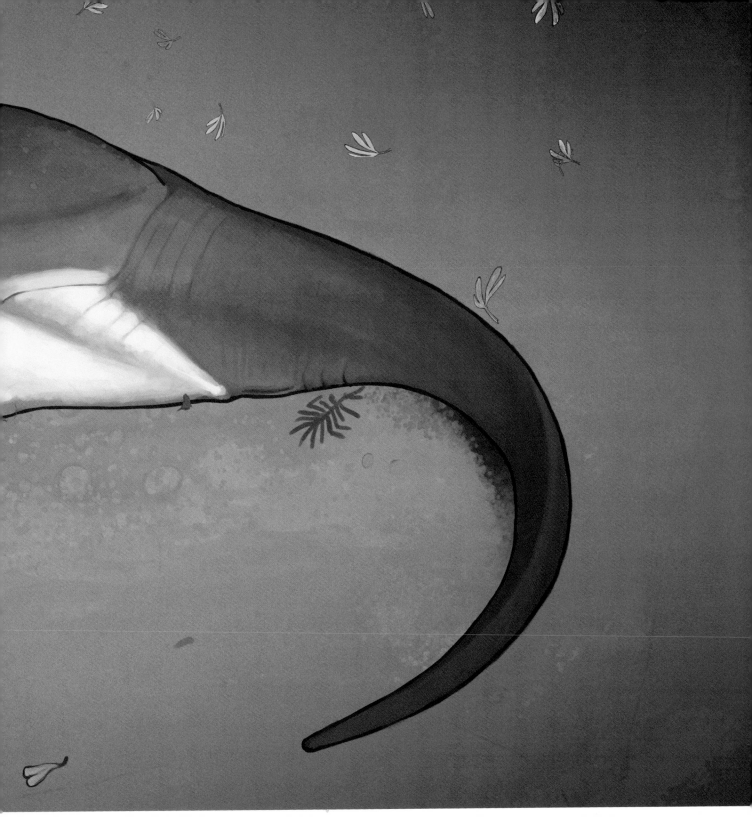

Protoceratops
climbing trees because they can

Reconstructing the behaviour of extinct animals is challenging, even if we assume a good correlation between anatomy and behaviour. Unfortunately, this correlation does not always exist in the real world. Elephants are excellent at swimming, crocodiles and alligators occasionally eat fruit and leaves, juvenile iguanas sometimes jump up at the moon at night, and goats in some areas often climb trees in order to browse. Animals do what they do, not necessarily because it is what they are good at, or even because their anatomy is suited to it, but simply because they can. As a result, unexpected behaviours are commonplace.

Here, the famous ceratopsian *Protoceratops* is engaged in something it has no obvious adaptations or reason to do: climbing trees. Protoceratops was a boar-sized herbivore that lived during the Late Cretaceous in Mongolia. It is related to the larger horned dinosaurs of North America such as Triceratops, and is thought to have retained the general appearance of their common ancestor.

Hundreds of *Protoceratops* skeletons are known, many preserved in spectacular and lifelike poses. One specimen is preserved locked in combat with a *Velociraptor*; others died in poses showing that they were struggling to dig out of the sand that buried them.

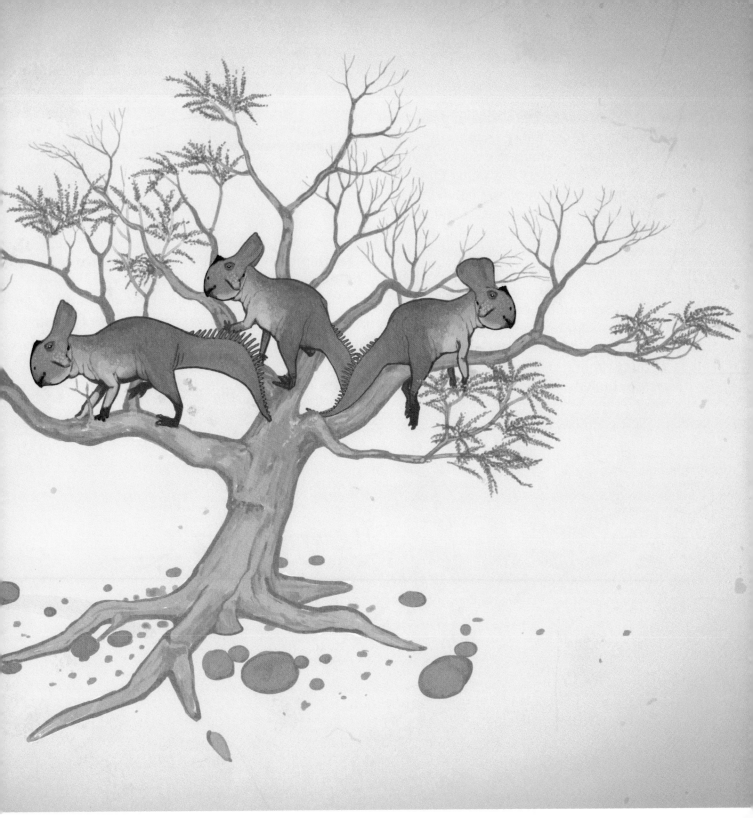

Majungasaurus
camouflaging as a log

Crypsis is a theme rarely explored in palaeontological art. Many present-day animals develop complex coloration schemes to disguise themselves from predators, prey, or both. Other animals match their appearance and behavior to different, usually poisonous species and "mimic" them for protection. While crypsis and mimicry are seen most often in smaller creatures, large-bodied animals also exhibit strange and confusing body patterns for disguise. A tiger's orange and black stripes might look dazzling in a zoo, but in its natural environment, they render it nearly invisible in the tall grass. Likewise, crocodiles blend in among swamps and riverbanks with their outline-breaking scutes and mottled coloration. At least some dinosaurs must have had similar camouflage schemes.

Can you see the *Majungasaurus* in this picture? Majungasaurus was a Cretaceous abelisaurid theropod from Madagascar, a strangely-proportioned relative of the *Carnotaurus* we saw earlier. Unless there is something very wrong with the fossils we have, *Majungasaurus* had an extremely long body, combined with very short legs and relictual arms, giving it the proportions of a bipedal, dinosaurian daschund. As you might have guessed, it is not clear how this predatory dinosaur moved about and hunted with such an atypical body plan. We imagined that camouflage, made possible by matching its pebbly scales to the texture of rocks or trees, made things easier for the strange old *Majungasaurus*.

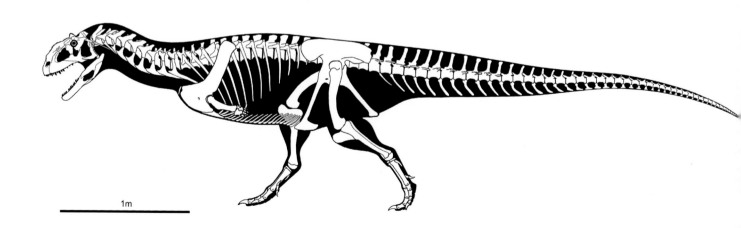

1m

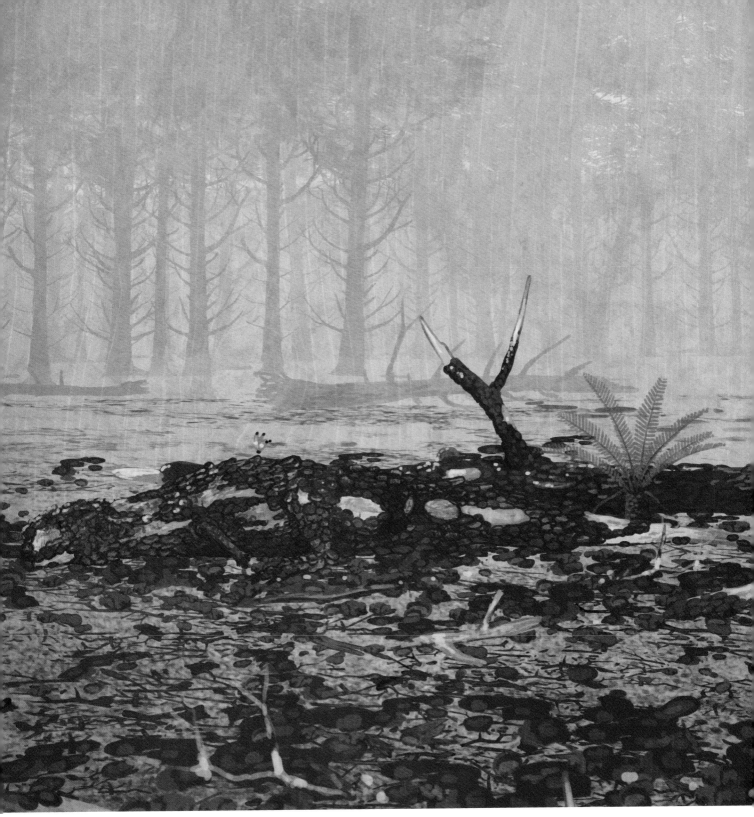

A Plesiosaur
hiding among coral

Camouflage is not limited to land animals. Rivers, lakes and seas also contain many risks, and many opportunities for hiding. The oceans especially teem with dazzling examples of crypsis; sea dragons that mimic every strand and and stalk of kelp, wobbegong sharks that lie down like mats of sand and seaweed, poisonous stonefish that are dangerously invisible among stones, and so on.

We imagined what sort of animals might have camouflaged themselves in prehistoric seas, and turned to long-necked marine reptiles known as plesiosaurs, as a possible example. **Plesiosaurs** were not dinosaurs, and instead belonged to a major group of marine reptiles called **sauropterygians**. The most successful, most diverse and most long-lived sauropterygians, plesiosaurs included the previously-mentioned elasmosaurs, the big-headed, macropredatory pliosaurs as well as a number of groups that are intermediate in shape and proportions.

We pictured this particular plesiosaur as a sit-and-wait hunter, lying in shallow coral reefs and waiting for suitable-sized prey to swim by. A near total absence of information on plesiosaur skin morphology means that we have no firm ideas about skin texture in these animals. It is assumed that most had a smooth skin for hydrodynamic efficiency, but we imagined this particular plesiosaur as a well-camouflaged hunter with an exceptional sit-and-wait strategy.

As an air-breather, the dive time of our camouflaged lurker would be limited, but could theoretically still be long enough to allow fruitful hunting in areas of rich prey density. The dorsoventrally compressed body shape present in at least some plesiosaurs[1] renders it possible that they could lie on the seafloor; intriguingly, the shallow-bodied Jurassic form *Tatenectes* also has particularly dense, heavy bone located on its underside and near its midline, suggested that it was using bone as a form of ballast to stay near (or on?) the seafloor. We speculate that some bottom-hugging plesiosaurs may have used their long necks for suction feeding - they would open their mouths and lunge up when a small fish or marine reptile wandered by. The rush of water filling the animal's long throat cavity would create a brief vacuum effect, helping it capture its victim.

1 O'Keefe, F. R., Street, H. P. , Wilhelm, B. C. , Richards, C. D. & Zhu, H. 2011. A new skeleton of the cryptoclidid plesiosaur Tatenectes laramiensis reveals a novel body shape among plesiosaurs. Journal of Vertebrate Paleontology 31, 330-339.

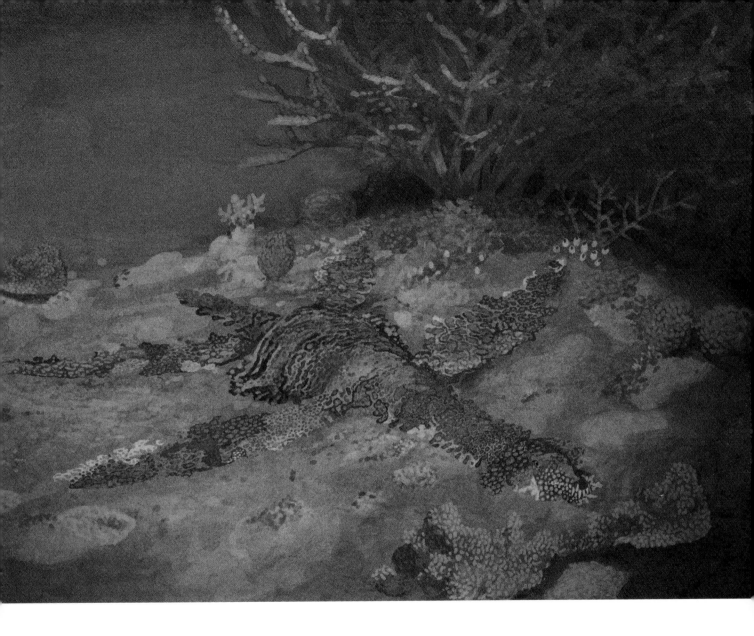

Ouranosaurus
... is not fat - it's the sail!

Nothing quite says "prehistoric" like an animal with a skin sail running down its back. This is possibly due to the "reptilian" nature of such baroque accessories - the only animals with sails on their backs today are cold-blooded, "exotic" lizards such as basilisks. Whatever its cause, this trend is so entrenched in popular culture that *Dimetrodon*, a sail-backed animal that lived millions of years before dinosaurs and was more closely related to mammals, is frequently lumped in with the ruling reptiles in children's books and toy sets. Even within dinosaurs, the popular desire to have ridge-backed monsters manifests itself with depictions of exaggerated skin sails in species with extended vertebral spines, such as the herbivorous ornithopod *Ouranosaurus*.

Tall vertebral spines on dinosaurs are usually interpreted as having supported "sails", with little flesh covering the bones. However, it is possible that these spines supported other tissues, such as fat deposits, or humps. This is exactly the case in large herbivores today such as bison, camels and rhinoceroses. Indeed, palaeontologist Jack Bailey published some reconstructions in 1997 in which he made *Ouranosaurus* and *Spinosaurus* look more 'hump-backed' than 'sail-backed'.[1]

Perhaps, however, this approach is wrong and tall-spined reptiles like chameleons, with narrow ridges that are neither sails nor a humps, provide better models for dinosaurs.[2] Nevertheless, this area remains understudied and we decided to reconstruct one of the more popular "sail-backed" dinosaurs with an armored hump on its back.

Behold *Ouranosaurus* in its hump-backed glory. *Ouranosaurus* was a large iguanodontian ornithopod that inhabited northern Africa during Early Cretaceous times. Several other distantly related dinosaurs from the same location also have elongated vertebral spines, including the enormous theropod *Spinosaurus* and the sauropod *Rebbachisaurus*. So perhaps, instead of just *Ouranosaurus*, the region was inhabited by an entire cast of unusual, hump-backed dinosaurs in real life.

The reason for such unusually synchronized convergent evolution, and indeed the very nature of these spines in life, remains unknown. Perhaps climactic factors or sexual selection could have played a role. Display is certainly a likely purpose - and certainly fits with the general idea that dinosaurs were flamboyant, social animals.

1 Bailey, J. B. 1997. Neural spine elongation in dinosaurs: sailbacks or buffalo-backs? Journal of Paleontology 71, 1124-1146.

2 Naish, D. 2010. Concavenator: an incredible allosauroid with a weird sail (or hump)… and proto-feathers? Tetrapod Zoology ver 2 http://tinyurl.com/9pypuf4

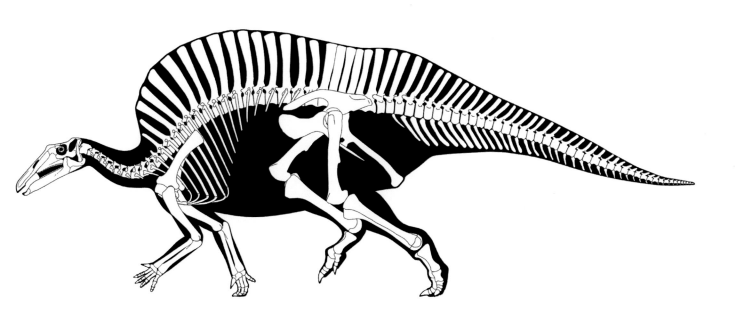

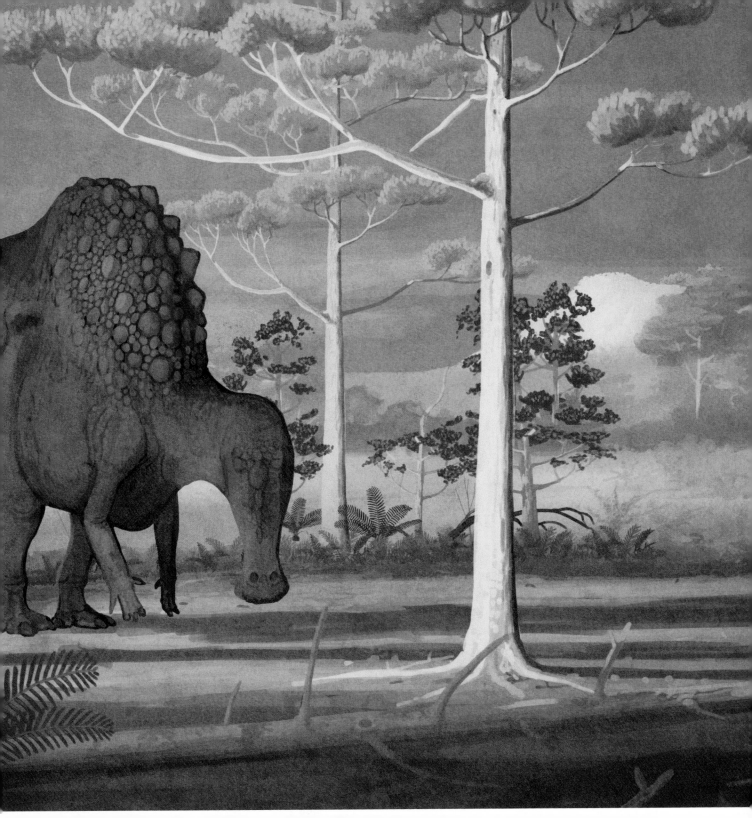

Parasaurolophus
fatter than we think?

Since the old view of dinosaurs as lumbering and shapeless piles of stocky lard was discarded, palaeontological artists have been keen to portray most dinosaurs as slim, sleek animals where every contour of the limbs, every muscle and even every bone can be clearly discerned. No living mammal, reptile or bird has such an illustratively visible anatomy. Living animals are replete with skin flaps, fat and saggy bits that obscure the exact lines of their bones and musculature.

The famous "duckbilled dinosaurs" known as **hadrosaurs** have provided us with some of the clearest fossils which prove that dinosaurs were not walking anatomical diagrams. Remarkable mummified hadrosaur specimens provide us with an unprecedented amount of information on hadrosaur soft tissue anatomy, and one of the most interesting features of these fossils is a series of vertical 'shoulder folds' that cover the upper arm and shoulder region. The famous palaeontologist Greg Paul has argued that these were evidently present in life, and must always be depicted in life reconstructions of these animals.[1] Here, however, we explore the possibility that these are actually artifacts of desiccation, and that they supported a heavy padding of fat and muscles in real life.

Behold our fat *Parasaurolophus* and the solidly-built *Lambeosaurus* with a flap-like throat pouch.

Parasaurolophus and *Lambeosaurus* are familiar hadrosaurs, recognisable by their spectacular head crests. Hadrosaurs were the dominant plant-eaters of the Late Cretaceous, and had evolved one of the most advanced chewing mechanisms seen in vertebrates. Their crests were hollow, and almost certainly would have been used to create loud honking sounds for communication.

1m

1 Paul, G. S. 1987. The science and art of restoring the life appearance of dinosaurs and their relatives - a rigorous how-to guide. In Czerkas, S. J. & Olson, E. C. (eds) Dinosaurs Past and Present Vol. II. Natural History Museum of Los Angeles County/University of Washington Press (Seattle and London), pp. 4-49.

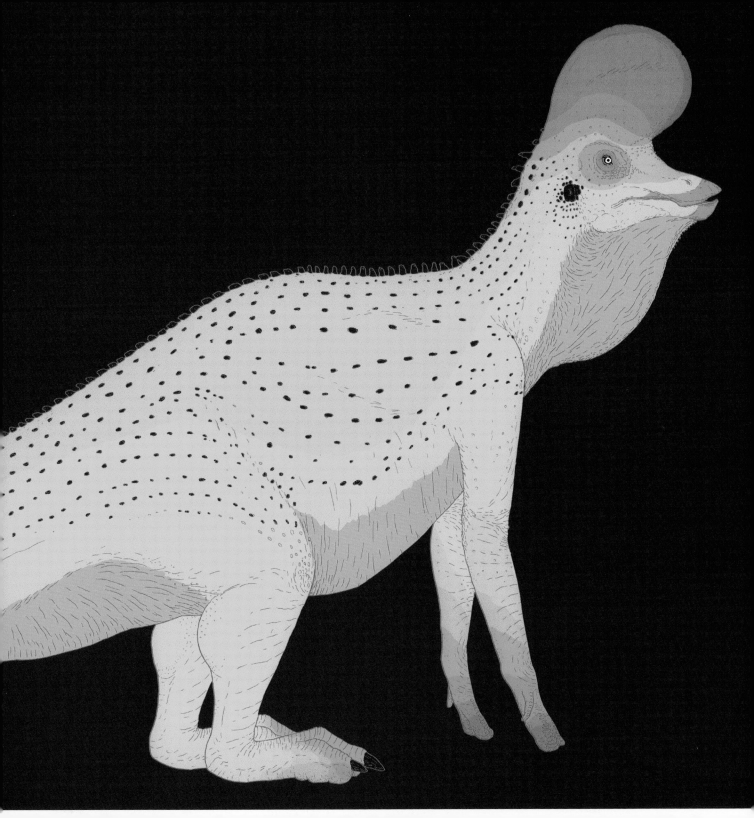

Therizinosaurus
a mountain of feathers

Some dinosaurs suffer from looking too exciting de-fleshed, leading artists to depict them in exciting and garish ways. If one group of dinosaurs could be singled out for their strangeness, the mystifying, long-clawed **therizinosaurs** would win hands (or claws,) down.

These animasl were originally known only from a set of giant, mystifying claws, the longest of which were more than 70 centimeters long. These claws prompted a whole range of theories and hypothetical identities.

Early ideas were that therizinosaurs might be gigantic, turtle-like beasts or vast, vicious predators which slashed open the bellies of sauropods and other large dinosaurian prey. Better remains led to suggestions that therizinosaurs were plant eaters: perhaps late-surviving prosauropods or relatives of early ornithischians, or even a completely unique lineage of dinosaurs distinct from any other group. With newer discoveries and the rise of cladistic methodology, it became clear that they were, in fact, aberrant herbivorous theropods, reasonably closely related to birds.

Even after scientists established what they were, depictions of therizinosaurs maintained a strong claw-based fetish. *Therizinosaurus* – shown here in our life reconstruction – was one of the later, more advanced forms. It was a large, elephant-sized animal with tremendously wide hips and (presumably) enormous guts. To be fair, it is difficult to ignore the sheer weirdness of these majestic animals; in real-life, however, exciting skeletons, claws and bellies are all covered up in a great big mounds of feathers, fur, or fat. Silhouettes are the most distinctly recognizable visual attributes of large animals today. As a result, our Therizinosaurus are not brandishing their meter-long claws in the viewer's face. Our opinion on palaeoart is that subtle references and hints of anatomical features are more realistic, more in line with what we see in living animals. Portrayed with style and in an appropriate setting, they can leave a more distinct effect on the viewer.

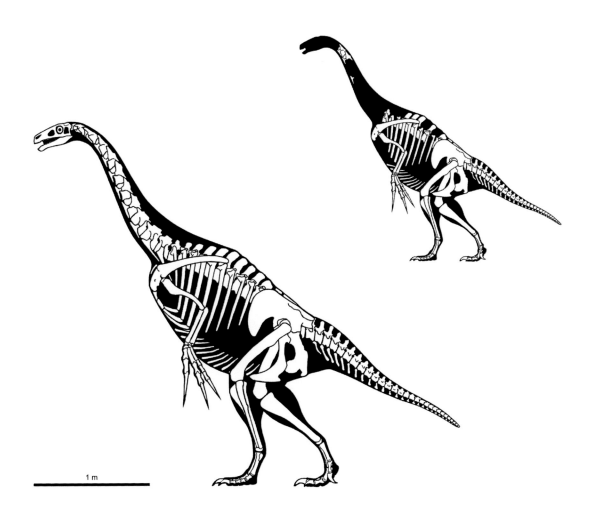

1 m

The skeleton of *Nothronychus mckinleyi* illustrates the strange anatomy of therizinosaurs.

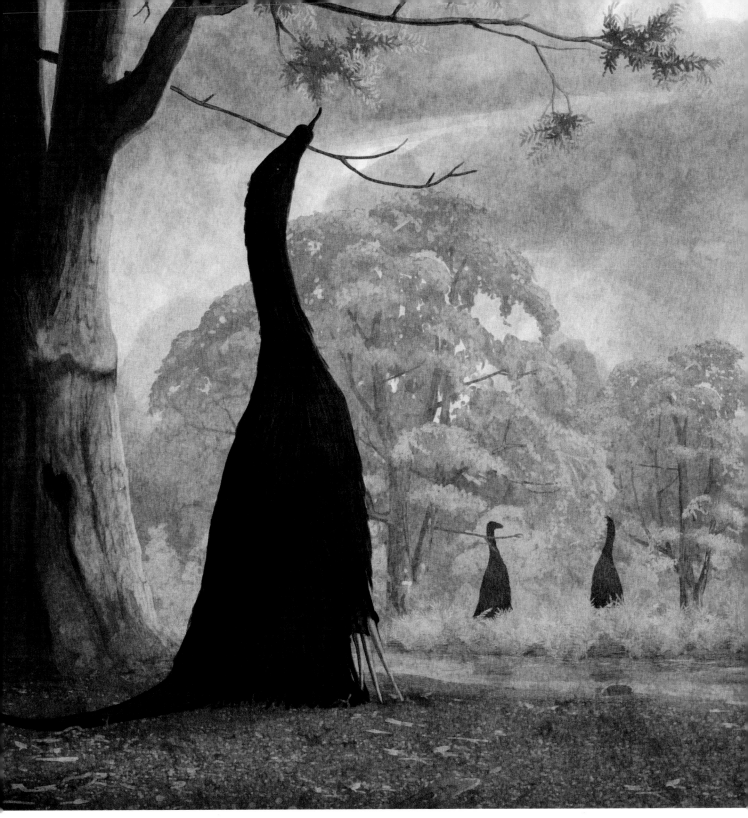

Heterodontosaurus
goes the whole (hedge) hog

Small **ornithischians**, the quintessential "harmless herbivores" of the prehistoric world, have had one of the greatest image changes of the dinosaur renaissance in the recent years. Traditionally, these animals were usually portrayed as smaller versions of their larger relatives. Unlike the meat-eating theropods, whose feathery integument is becoming more-or-less common knowledge thanks to dozens of new well-preserved fossil discoveries, artists and scientists were reluctant to dress small ornithischians in feathers or "dinofuzz."

When illustrated, these generic, naked herbivores were mostly shown running, either away from a more interesting predator, or simply scampering across the landscape with no purpose or aim. However, recent discoveries have shown that there is far more to small ornithischians than previously assumed. To begin with, they are no longer naked: dermal quills are now thought to be present in almost all small ornithischians after the discovery of the Chinese heterodontosaurid *Tianyulong* (preserved with a covering of spike-like body hairs[1]) and of the early ceratopsian *Psittacosaurus* (one specimen is preserved with bristle-like structures on its tail[2]). Another exciting discovery, this time of an ornithopod called *Oryctodromeus*, has revealed that at least some small ornithischians had burrowing habits, and spent at least part of their time sheltering together in dens.[3] Perhaps these dens were composed of family units. Taken altogether, these discoveries paint a very different picture of small ornithischians. No longer are they defenseless bipedal 'lizards', but an unique group of animals with their own extraordinary adaptations and social behavior.

This picture shows a family group of *Heterodontosaurus* near the entry of their collective burrow. Taking the latest discoveries into account, we reconstructed them with a full set of porcupine-like quills for defence. *Heterodontosaurus* was a small, basal ornithischian from the Early Jurassic of South Africa. It's name ("differing tooth lizard") refers to its unusual dentition.

Heterodontosaurus had the beak and chewing teeth common to most ornithischian dinosaurs, but it also had large "canines" and two other types of teeth that helped it chew its food efficiently. Scientists still aren't sure if *Heterodontosaurus* was purely herbivorous, or if it supplanted its diet with small animals as well.

1 Zheng, Xiao-Ting; You, Hai-Lu; Xu, Xing; Dong, Zhi-Ming (19 March 2009). "An Early Cretaceous heterodontosaurid dinosaur with filamentous integumentary structures". Nature 458 (7236): 333–336. doi:10.1038/nature07856. PMID 19295609.

2 Mayr, G., et al. (2002) "Bristle-like integumentary structures at the tail of the horned dinosaur Psittacosaurus." Naturwissenschaften, Vol. (89), pp. 361-365

3 Varricchio, David J.; Martin, Anthony J.; and Katsura, Yoshihiro (2007). "First trace and body fossil evidence of a burrowing, denning dinosaur". Proceedings of the Royal Society B: Biological Sciences 274 (1616): 1361–8

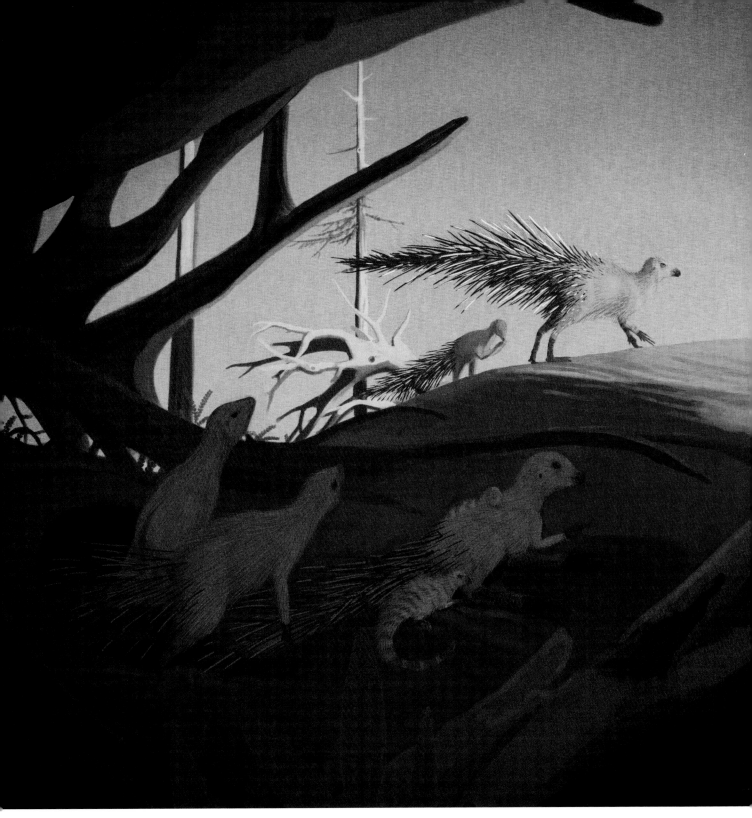

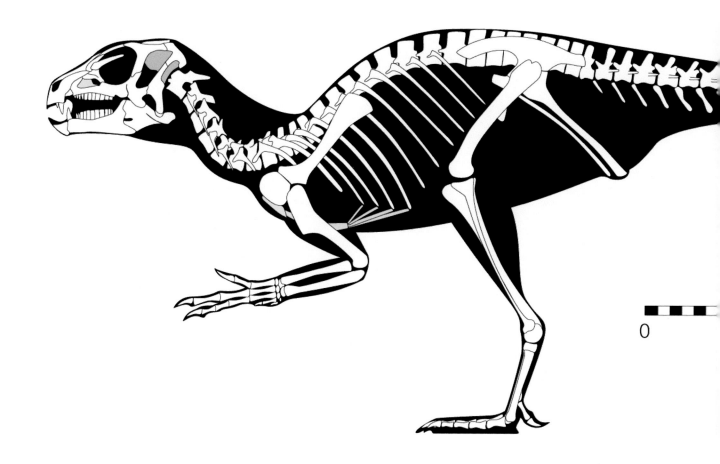

0

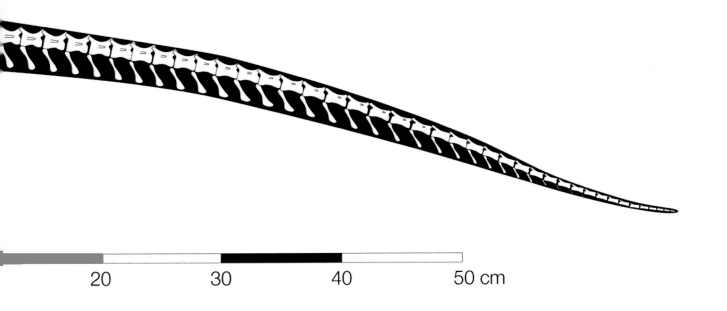

Leaellynasaura
in a fluffy guise

As seen before with *Hypsilophodon*, many small plant eating dinosaurs will have their popular images greatly revised thanks to new discoveries of social behaviour and body integument. Instead of looking like two-legged iguanas, these animals will have to be re-imagined with the extra possibilities offered by furry bodies and communal living habits.

Here is one more small ornithischian re-interpretation, this time featuring *Leaellynasaura*. This dinosaur was discovered in Australia, where it lived during Early Cretaceous times, about one hundred and ten million years ago. At that time, Australia was located close to the Earth's geographic south pole. Although its climate was possibly not as cold as today's Antarctic, the axial tilt of our planet meant that Cretaceous Australia did not receive direct sunlight for long periods of time, and almost certainly experienced sub-zero temperatures.

Aside from being a **polar dinosaur**, *Leaellynasaura* was also extraordinary for its immensely long tail, which was almost three times as long as its body. Nobody knows why *Leaellynasaura* had such a long tail, or what it used it for. Theories range from the tail being used as a climbing aid, a sexual and social display feature, or a long, shaggy "scarf" that the dinosaur wrapped around itself as protection from the cold. It has even been suggested that the tail aided the animal in swimming!

Drawing on these facts, we reconstructed *Leaellynasaura* as a rotund furball that scurried peacefully about in the polar forests of Australia's past. We imagined its long tail as a thin, signalling "flagpole" that helped it identify and keep close to members of its pack. No doubt some people will find this reconstruction preposterous, and perhaps they will be right. However, we felt that not enough dinosaurs were reconstructed as "cute" beasts, whereas in nature, polar animals can look quite pulchritudinous under layers of fat, muscle, fur and other insulation.

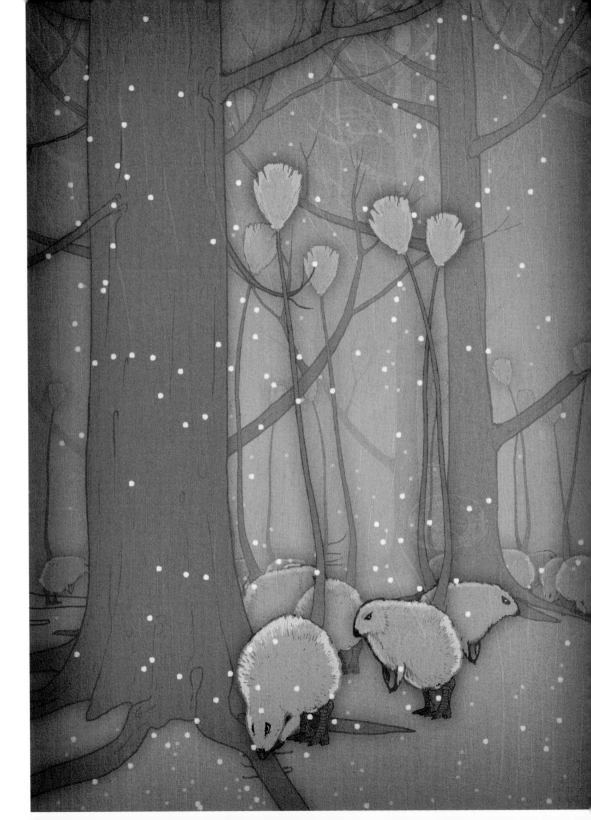

Microraptor
as a proper bird

Almost twenty years of fossil discoveries have firmly established that certain small, meat eating dinosaurs were covered in feathers, to such a degree that even popular science books routinely depict these animals with some sort of integument.

Yet many palaeoartists, it seems, still have difficulty picturing such small, feathered theropods as **bird-like creatures.** Instead of picturing the coherent, well-rounded forms that are found in nature, most artists over-focus on certain features or details of preservation found in a single fossil, and repeat and exaggerate them to picture "little monsters" that look more like film creatures more than real animals. When examined in detail, this typecasting can tell us a lot about trends in palaeoart.

The small theropod *Microraptor* is a case to the point. This small, possibly flying relative of *Velociraptor* and *Archaeopteryx* was described in 2003 as a "four-winged dinosaur"[1] amid much media hype. Since then, almost every reconstruction of this animal has depicted it as a strange, dragon-like feathered glider with a reptilian face. In almost every picture, *Microraptor* is seen spreading its arms and legs, all lined with feathers that stick out as visibly as possible, as if to prove to the viewer that it really had "four wings." Such illustrations might be educational, but they also help popularize an image of the animal that was not real. It's as if artists are unable to conceive of dinosaurs that don't look abnormal and "alien" in some way.

When illustrating *Microraptor*, we wanted to "filter out" all popular repetitions and approach it from scratch. The animal was indeed remarkable for having wing-feather-like structures on its rear legs, but we knew from natural observation that flying animals rarely have their wings fully visible when resting. Our result looks far more naturalistic, and far less like the spread-eagled fantasy creature that popular audiences have come to associate with *Microraptor*.

On a side note, we gave our *Microraptors* a nest in order to add depth to their story. The nesting behaviour of dinosaurs is a complex issue that deserves further discussion and speculation, but it seems likely that this varied immensely, just as it does in modern birds.

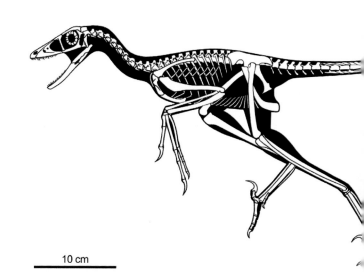

10 cm

1 Xu, X., Zhou, Z., Wang, X., Kuang, X., Zhang, F. & Du, X. 2003. Four-winged dinosaurs from China. Nature 421, 335-340.

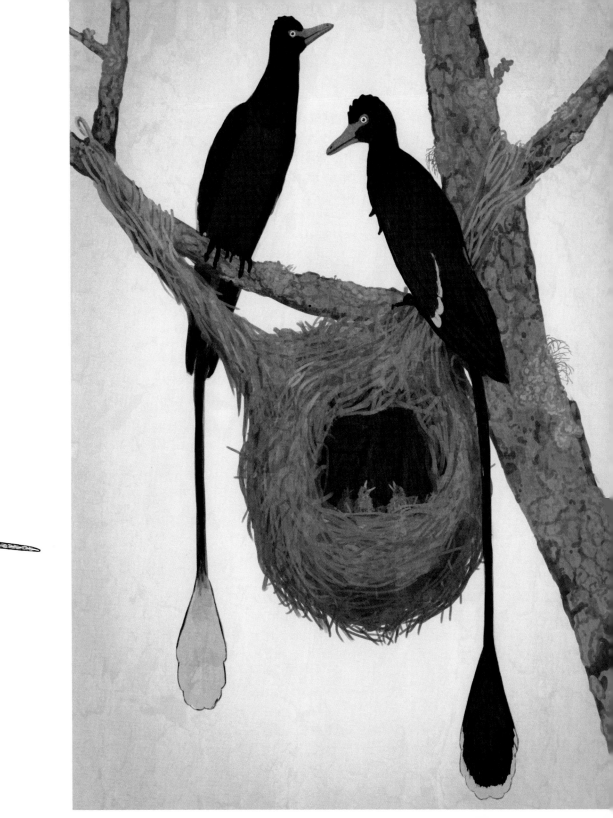

Triceratops
not looking as expeced

Even the most familiar of dinosaurs may hold great surprises in their life appearance. It seems that every time the soft tissue of a dinosaur is discovered, our views of that animal, and usually all of its relatives as well, are changed drastically. Such revelations show how artificial our images of even the most well-known dinosaurs can be. What we are drawing all the time may not be the "real" animals themselves, but **artifacts of an artistic tradition.**

An example is *Triceratops*, arguably one of the most recognizable dinosaurs on the planet. This animal has always been seen as a sort of dinosaurian rhinoceros, with its iconic head frill, three horns and giant, plant-cropping beak. In recent years, however, scientists have made several discoveries that may drastically revise our image of this animal. Fossil skin impressions (mentioned online in 2010, but unpublished at the time of writing) apparently reveal that *Triceratops* had nipple-like protuberances located within the centres of the scales that cover its back and tail: it is inferred that these structures anchored quill-like structures of some sort. Moreover, other fossils show that an earlier member of the horned dinosaur family, *Psittacosaurus*, had a fringe of long, spine-like filaments lining the upper surface of its tail.[1] Since *Psittacosaurus* was close to the ancestry of all large-bodied, horned dinosaurs, it would not be unreasonable to suggest that all ceratopsians possessed some sort of spiny integument.

1 Mayr, G., Peters, D. S. & Plodowski, G. 2002. Bristle-like integumentary structures at the tail of the horned dinosaur Psittacosaurus. Naturwissenchaften 89, 361-365.

Following this line of deduction, we produced this unfamiliar depiction of the very familiar *Triceratops*. What if the unusual dermal nipples of *Triceratops* were the bases of giant protective spines?

While we are not suggesting that this was the definitive look of this animal, it wouldn't surprise us if *Triceratops*, or other, even less-expected dinosaurs bore a covering of spiky hairs.

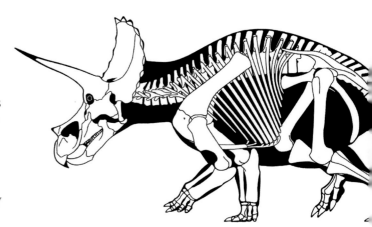

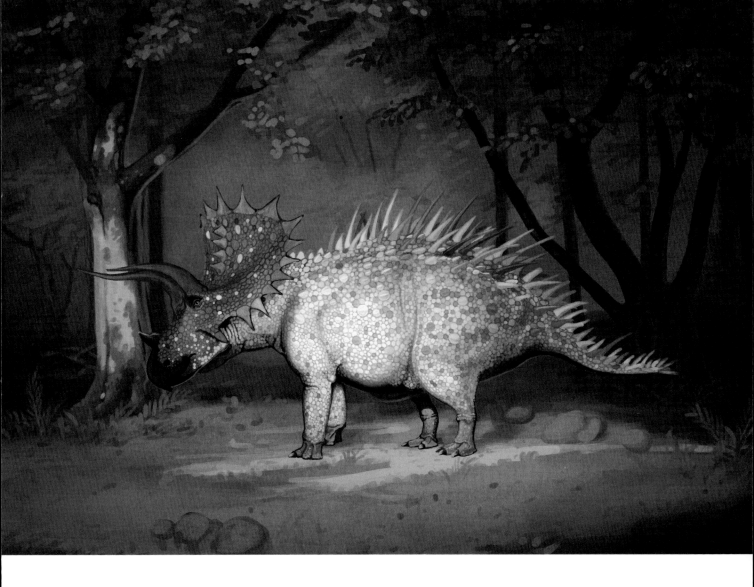

Opisthocoelicaudia
everything old is new again

The oldest dinosaur stereotype is that of the massively dumb, long-necked sauropod, dragging itself slowly out of a fetid swamp. Once pictured as too big to support themselves on land, sauropod dinosaurs have long since been **lifted out of the marshlands.** Thanks to new fossil discoveries and unbiased considerations of the anatomical and palaeoenvironmental evidence,[1] we now know that most sauropods lived on land, moved about on erect legs and did not drag their tails on the ground.[2]

Numerous recent discoveries have also revealed that sauropods were far more diverse and complicated than originally assumed. There were tall, long-limbed forms such as *Brachiosaurus* and *Giraffatitan*, long and lean, whiplash-tailed form such as *Diplodocus*, and strangely proportioned forms such as the short-necked *Brachytrachelopan*[3] and the weird *Isisaurus*[4] with its wide, deep neck and unusually proportioned limbs. Isolated island habitats led to the evolution of dwarf, cow-sized sauropods such as *Europasaurus*[5].

Within this diversity, how sure are we that sauropods were all landlubbers? As we can see from hippopotamuses and certain Asian rhinoceros species today, large herbivores don't need to be cold-blooded dimwits in order to pursue partially aquatic lifestyles. Perhaps the same was also true for members of some sauropod lineages.

If we could bet on the possibility of a certain sauropod being at least partially aquatic, our money would be on *Opisthocoelicaudia*, a titanosaur from the Late Cretaceous of Mongolia. Known from a famous fossil that preserved a more-or-less complete body and limbs but, frustratingly, has no head or neck preserved, it was surprisingly rotund animal, with short legs and a massive, round body. Its tail vertebra fit together via flexible ball-and-socket joints, and its tail preserves evidence of massive ligamentous and muscular attachments. It is not difficult to imagine these adaptations as modifications for a mostly water-based mode of existence. While today's Mongolia doesn't sound like the best place to find water-dwelling dinosaurs, the area was a lush, fertile zone crossed by many rivers during the time Opisthocoelicaudia lived. At the time of writing, no technical study has properly addressed the possibility of aquatic life for *Opisthocoelicaudia*, but its proportions certainly recall those of fossil mammals suggested to be amphibious.[6] Those who know their palaeoart will of course recognise our illustration as a homage to part of the Zallinger mural.

1 Bakker, R. T. 1986. The Dinosaur Heresies. Penguin Books (London).
2 Bakker, R. T. 1971. Ecology of the Brontosaurs. Nature 229, 172-174.
3 Rauhut, O. W. M., Remes, K., Fechner, R., Cladera, G. & Puerta, P. 2005. Discovery of a short-necked sauropod dinosaur from the Late Jurassic period of Patagonia. Nature 435, 670-672.
4 Jain, S. L. & Bandyopadhyay, S. 1997. New titanosaurid (Dinosauria: Sauropoda) from the Late Cretaceous of central India. Journal of Vertebrate Paleontology 17, 114-136.
5 Sander, P. M., Mateus, O., Laven, T., Knötschke, N. 2006. Bone histology indicates insular dwarfism in a new Late Jurassic sauropod dinosaur. Nature 441: 739-741.

6 Mihlbachler, M. C., Lucas, S. G., Emry, R. J. & Bayshashov, B. 2004. A new brontothere (Brontotheriidae, Perissodactyla, Mammalia) from the Eocene of the Ily Basin of Kazakstan and a phylogeny of Asian "horned" brontotheres. American Museum Novitates 3439, 1-43.

All Todays

Although the accumulation of discoveries and fossil insights have given us a more-or-less clear view of some extinct animals, many are still reconstructed with a rule-of-the thumb methodology. As we saw in the previous section, this modus operandi does not take soft tissues, integument, colour and behavioural elements into account. More recently, palaeontological artists have began to notice these shortcomings and have begun to include more lifelike (if slightly speculative) elements in their reconstructive work.

In this section, we took the opposite approach and tried to highlight what some reconstructions might be missing out by "reconstructing" modern animals from their skeletal diagrams. We took the position of speculative observers with some knowledge of how vertebrate bones and muscles work, but with no information on the lifestyles, soft tissues or the integument of their subjects. We applied this approach to a number of modern-day animals such as birds, ungulates, carnivores, whales and reptiles, with extraordinary and sometimes hilarious results.

"Shrink Wrapping"
How will future artists depict anatomy?

As we have already discussed, the modern, sleek versions of dinosaurs have become a cliché. Dinosaurs have been stripped of extraneous soft tissue, with every muscle and bone ridge carefully portrayed as visible in life. It has become fashionable to reconstruct theropods with every ridge and fossa on their skulls echoed by lines of scale, with skull bones given maximum visibility.

Perhaps palaeontological artists of the future will give modern animals the same treatment. They will want to flaunt their knowledge of mammalian anatomy by staying faithful to every limb bone, every finger, every indentation in the skulls. Some will be bolder than the rest, and decorate their creations with a light sprinkling of hairs, or apply garish color schemes. To be honest, it won't be easy to blame them, since there is only the most tenuous of correlations between bone textures and actual soft tissue in living animals.

Can you guess which animals are depicted on the following pages? The answers, as explained by the unknown scientists that will discover and depict them in the future, are visible next to each image.

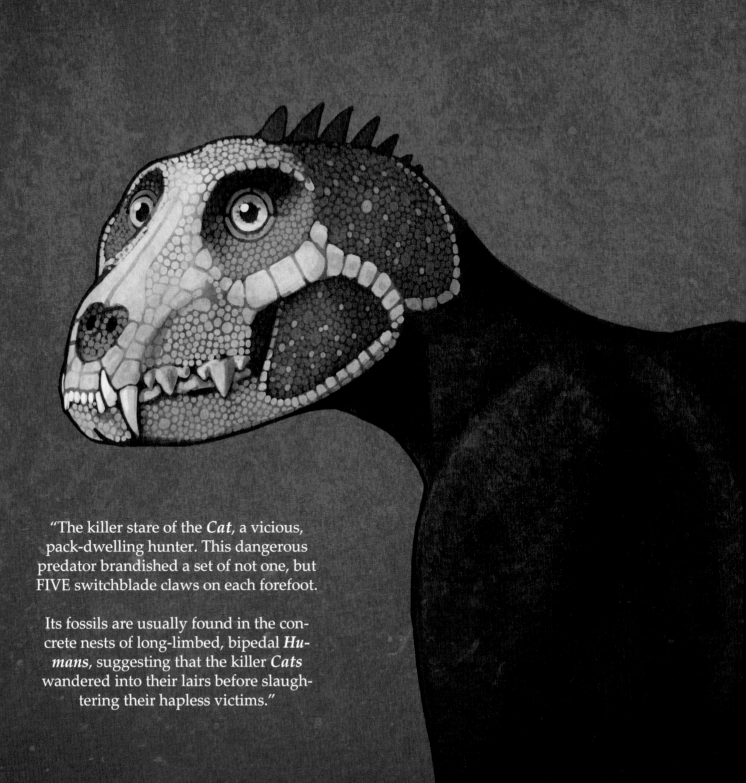

"The killer stare of the *Cat*, a vicious, pack-dwelling hunter. This dangerous predator brandished a set of not one, but FIVE switchblade claws on each forefoot.

Its fossils are usually found in the concrete nests of long-limbed, bipedal *Humans*, suggesting that the killer *Cats* wandered into their lairs before slaughtering their hapless victims."

"Only the skull of the *Hippopotamus* is known, yet even that is enough to tell that this apex predator was the most dangerous hunter of its period.

Its long teeth and heavy jaws were strong enough to chew right through the metallic armor of *Cars.*"

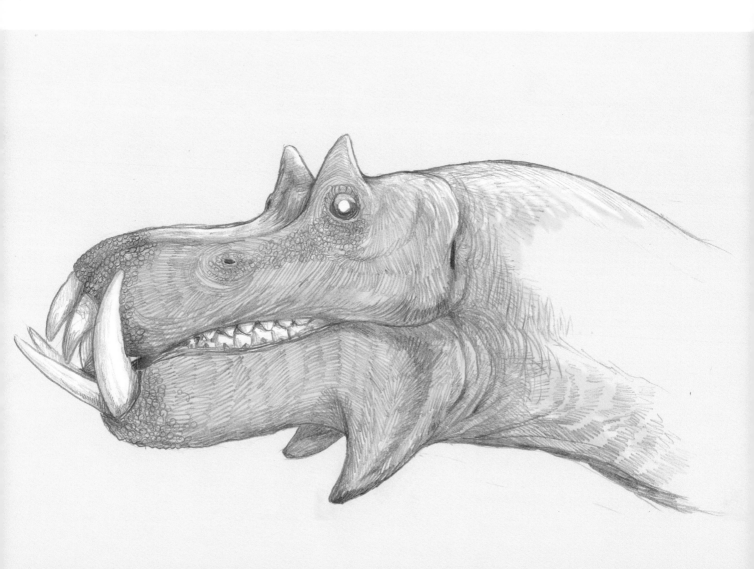

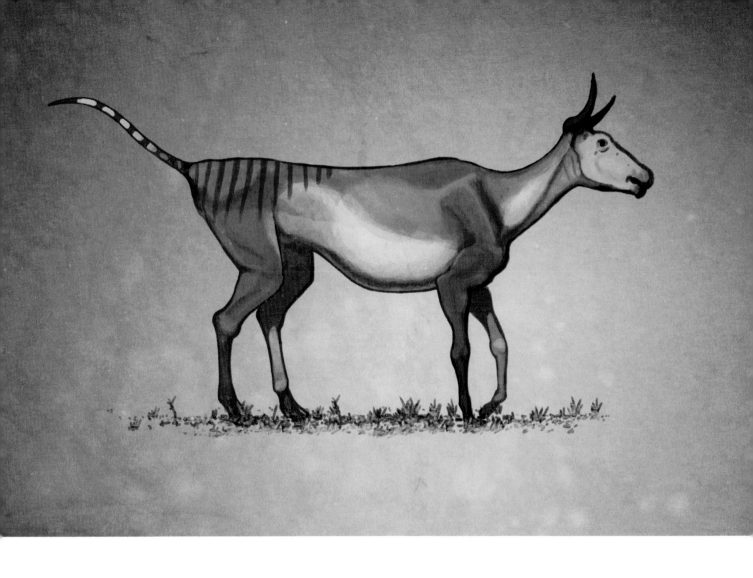

"The *Cow* was a lithe, graceful herbivore that despite its size, could easily outrun pursuing hunters."

"With its extraordinary skin sail, the *Rhinoceros* was among the strangest of the Holocene herbivores.

Researchers suggest that this organ might have helped it shed excess heat."

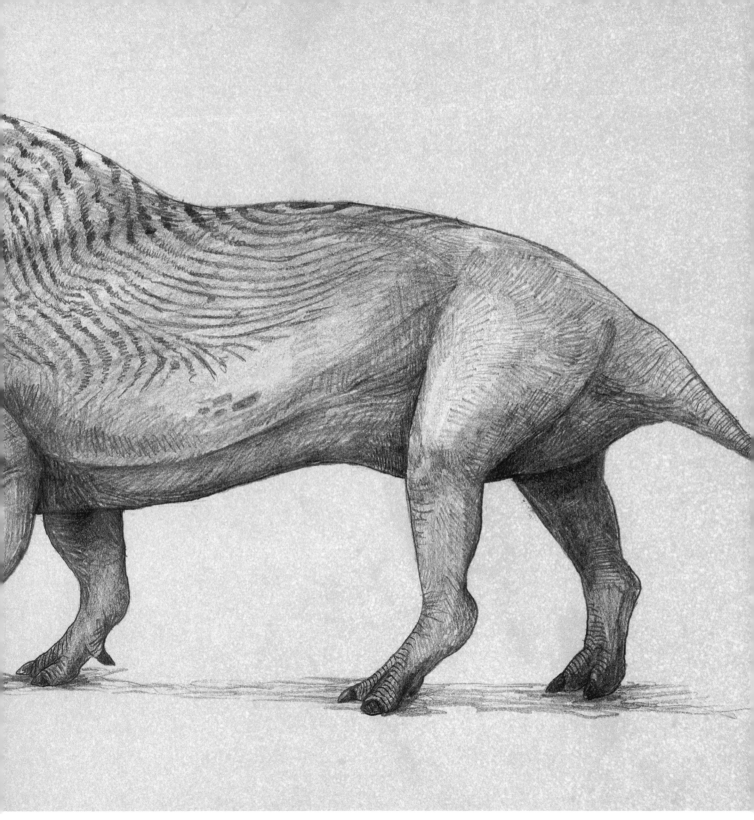

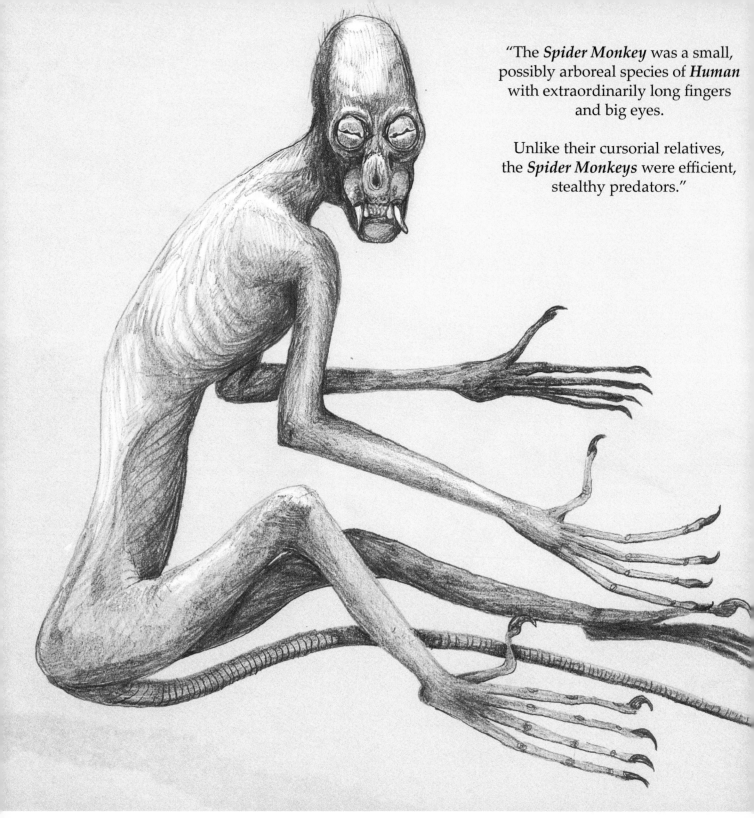

"The *Spider Monkey* was a small, possibly arboreal species of *Human* with extraordinarily long fingers and big eyes.

Unlike their cursorial relatives, the *Spider Monkeys* were efficient, stealthy predators."

"A *Toad* ambles merrily along the Holocene forest floor. This reconstruction is now considered to be erroneous since the long hindlimbs indicate that *Toads* were possibly bipedal."

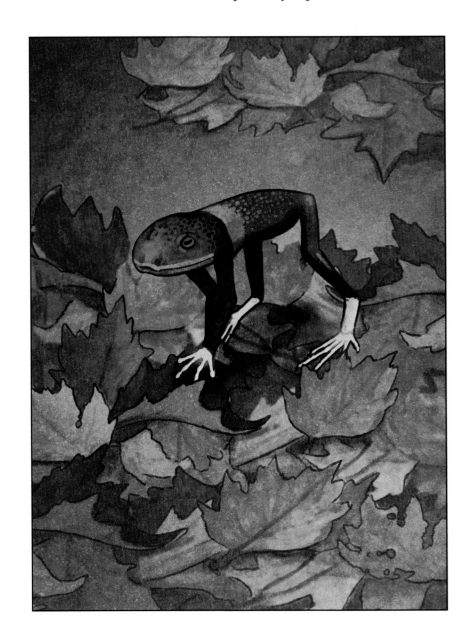

The Integument Problem
Covering up is not easy

If no feathers are preserved in the fossil record, will future palaeontologists guess at their presence? It seems unlikely. They will possibly recognise that birds had wings, but fill them in the simplest way: a membrane of skin. What about the other way around? Will errors of preservation, or of phylogenetic bracketing lead to mistaken assumptions of furry body covering?

Only time will tell.

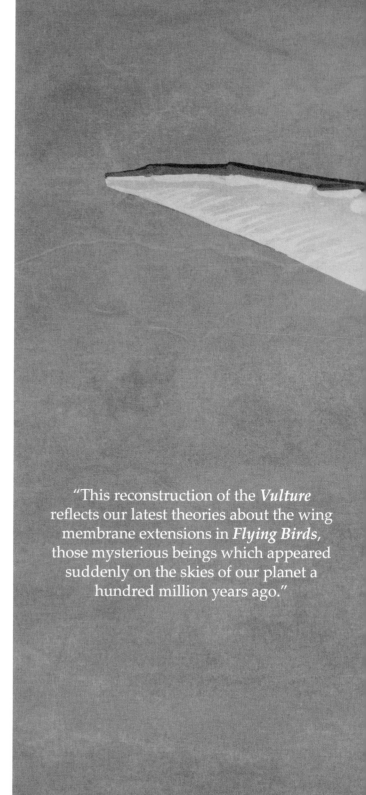

"This reconstruction of the *Vulture* reflects our latest theories about the wing membrane extensions in *Flying Birds*, those mysterious beings which appeared suddenly on the skies of our planet a hundred million years ago."

"Two *Swans* are seen with their long, scythe-like forelimbs, which they must have used to spear small prey items. One of them has just caught a *Tadpole*, one of the mysterious fish of the past."

"Two *Casque-Headed Hornbills* duel for dominance. These strange beaked animals grew elaborate head horns for competition."

"Unlike many others, this reconstruction of the *Iguana* is fully up-to-date. Impressions of a furry integument have been discovered around the skeletons of *Rats* a few years ago.

It is likely that all small *Vertebrates* had such body covering against the cold."

Wrung Necks
the biomechanics of rabbits

Palaeontology is an imperfect and difficult science. Many methodologies are brought to bear, and many contingencies must be considered. Since 1999, Kent Stevens and colleagues have argued that the vertebral joints of sauropod dinosaur necks can be effectively modelled in digital space using a specially designed piece of software called Dinomorph. The overriding conclusions from this work are that neck flexibility in sauropods was rather restricted, and that sauropod habitually held their necks in a more or less horizontal pose.[1]

However, other researchers have argued that this work fails to take proper account of the soft tissue anatomy present in animals. It ignores, for example, the substantial contribution that cartilage makes to neck flexibility, nor is it informed by the fact that virtually all living terrestrial amphibians, reptiles, birds and mammals habitually hold their necks in an elevated pose relative to the long axis of the dorsal vertebrae.[2]

Perhaps, not realizing that neck posture in living animals is not reflected properly in the way neck bones fit together, future palaeontologists will model such living animals as rabbits in the same way, concluding that they, too, held their necks horizontally.

This illustration thus serves as a warning against overly mechanistic approaches to anatomy.

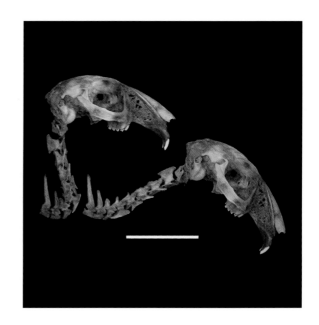

1 Stevens, Kent A, and J Michael Parrish. "Neck posture and feeding habits of two Jurassic sauropod dinosaurs." Science 284.5415 (1999): 798-800
2 Taylor, Michael P, Mathew J Wedel, and Darren Naish. "Head and neck posture in sauropod dinosaurs inferred from extant animals." Acta Palaeontologica Polonica 54.2 (2009): 213-220.

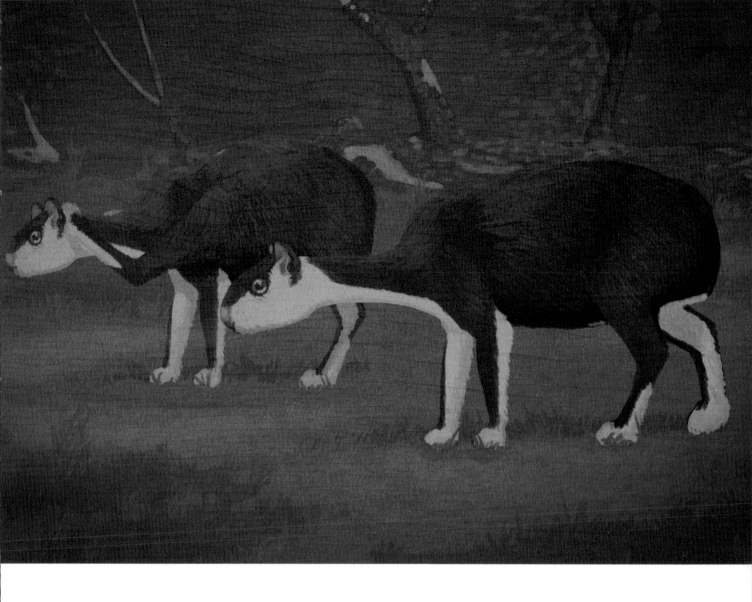

The Unknown Unknowns
Too conservative? Too cautious?

Fossils are rarely complete. Naturally enough, we tend to fill in the missing bits with conservative parts from the closest relatives whenever we can. The problem is, the defining anatomical features of many living animals are entirely composed of soft-tissue, which is hard to predict, even with educated guesswork. How daring and how correct will the palaeontologists of tomorrow be?

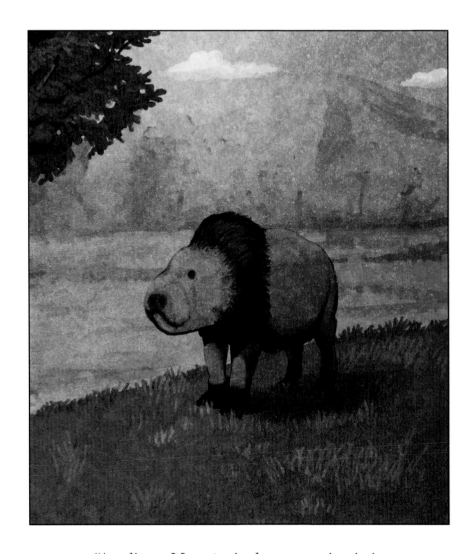

"A solitary *Manatee* is shown grazing in its
mountain home.

We only know the skull of this
enigmatic herbivore."

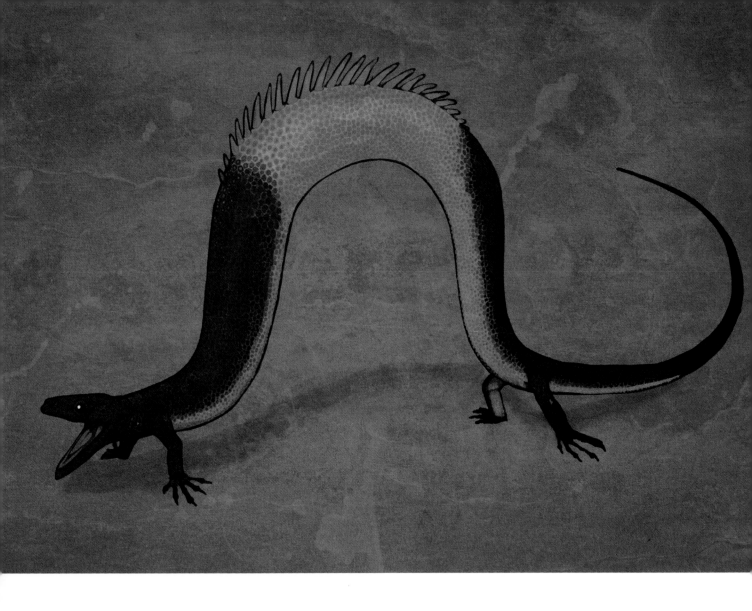

"A **Python** rears up in a colorful, defensive body display. We know this strange animal from fragmentary remains only, but it is likely that it supported its long body with stubby legs, much like those of closely-related **Lizards**."

"A bull *Elephant*, one of the gigantic mammals of ancient Africa, is shown here inflating its balloon-like facial sac.

Some fanciful reconstructions depict *Elephants* with even longer muscular appendages projecting from their faces, but this is unlikely since no modern mammals have such organs."

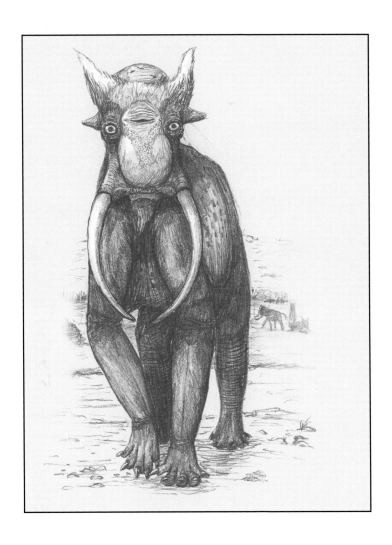

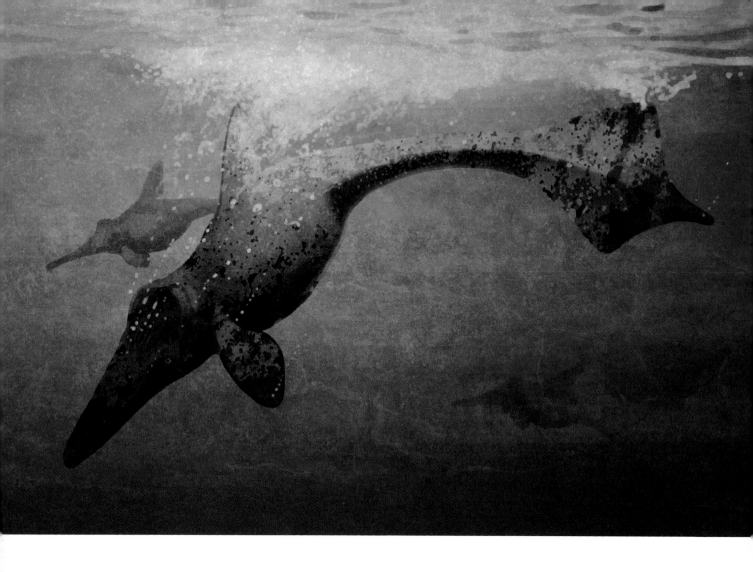

"The enigmatic *Whales* were some of the larg-
est animals to swim in the ancient oceans. Here,
we can see a couple of predatory *Sperm Whales*
looking for prey.

"Another dangerous predator, the elongated, serpentine *Bowhead Whale*, is visible swimming through a tangled underwater forest. This extremely derived predator fed on animals as big as itself, which it trapped with its gigantic, extensible jaws."

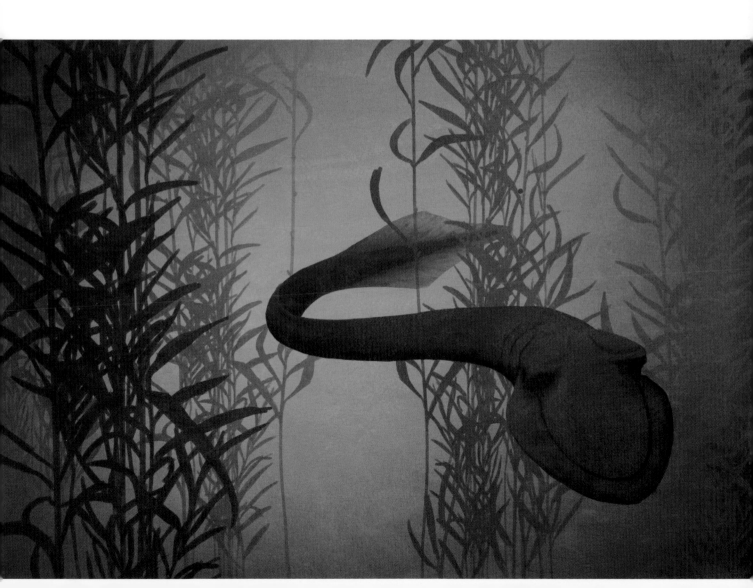

Venomous Baboons?

Modern palaeontology has its fair share of strange and outlandish hypothesis floating around, and these frequently find their way into artworks and illustrations. What kinds of strange and uninformed hypotheses might be formulated about present day animals?

Lacking any and all knowledge of the thick woolly coats and brightly coloured, naked skin patches and large guts of living baboons, it seems plausible that these lightly built, long-muzzled, fanged primates would be reconstructed as gracile terrestrial predators. Furthermore, those giant fangs have grooves running down their sides - a feature normally regarded as as key signature of the ability to produce venom, and inject it into the tissues of other animals. Perhaps the complicated nasal sinuses of baboons might be interpreted as space for venom glands.

Baboons, of course, are not venomous, quite why they have fang grooves isn't entirely clear. Knowing this, suggestions of venomosity sound more than a little preposterous. However, it will be surprising to know that very similar theories have been proposed for quite a few fossil animals: the most notorious recent example being the bird-like theropod dinosaur *Sinornithosaurus*.[1] This hypothesis was later rebuked by a number of experts, but not before it had been reported by a number of media sources as a legitimate discovery.

Thus, this case also illustrates the importance of proper science reporting in facilitating or limiting the spread of untrue or unproven ideas.

1 Gong, E., Martin, L. D., Burnham, D. A. & Falk, A. R. 2010. The bird-like raptor Sinornithosaurus was venomous. Proceedings of the National Academy of Sciences 107 (2010): 766–768.

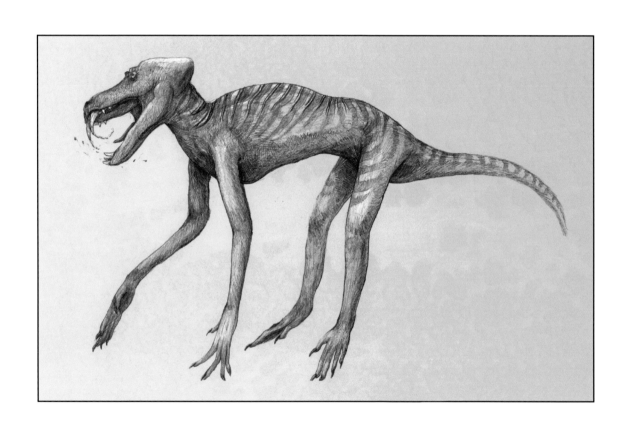

Hummingbird Vampires?

Would it be obvious that the slender, tubular (and sometimes serrated) bills of hummingbirds were used to probe deep into flowers and feed on nectar, or would alternative hypotheses be entertained? There is much reason to think so.

A hummingbird's skeleton is among the strangest in the animal kingdom. Their wings are tiny, in fact shorter than their legs. The large, strongly curved foot claws hint at a lifestyle involving clinging and climbing, as do small curved claws on the distinctive elongate hands.

Combine all of these features with a lack of evidence for their true lifestyle, and we imagine that future palaeontologists could misinterpret hummingbirds entirely. Vampiric hummingbirds sound unlikely, but similar theories have been proposed about Vampiric pterosaurs. In 2003, researcher David Peters claimed that he had discovered "rattlesnake fangs" and other indications of a blood and egg-sucking lifestyle in a small anurognathid pterosaur known as *Jeholopterus*. However, Peters' controversial research methods involved manipulating images in a computer to discern features that no other observer can see. Both this methodology and Peters' hypothesis of vampiric pterosaurs were consequently disproved by other scientists.

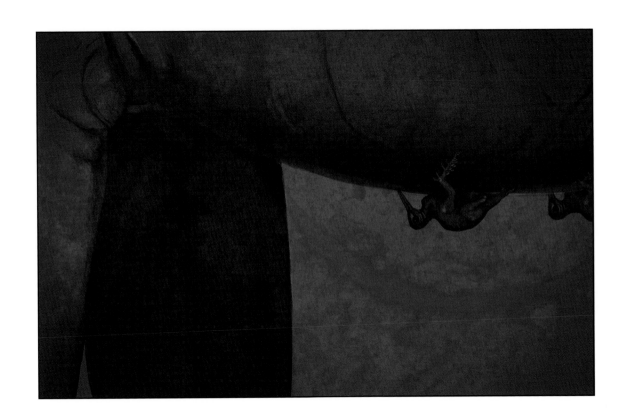

Homo diluvii
epilogue and reflection

Having shown you a fair share of speculations, oddities and unusual theories, we conclude our tour with perhaps the oldest "wrong reconstruction" of them all. Behold Homo diluvii - The Man of the Deluge. Described in 1726 by the Swiss Scholar Johann Jakob Scheuchzer from giant salamander remains, the creature was thought to be an actual human being, fossilized after drowning in the mythical deluge of the Bible.

This mistake seems so obvious now that even children could realize that the skeleton was not that of a human being. But Homo diluvii shows us how we take scientific reasoning and our repository of evidence and theories for granted. Science was still at its infancy at the time this fossil was discovered. People didn't understand what fossils were and tried to explain them with concepts they had at hand, which invariably came from religious myths at the time. Scholars were incapable of even conceiving that animals could leave their remains as fossils in rock, or that different animals and plants lived at different times, or that organisms could go extinct. Thus, a salamander ended up a man in their worldview.

Over the centuries, we have come a long way from Homo diluvii. We now know what fossil animals are, and can reliably formulate their relationships to living beings today. Almost with each passing day, new discoveries are providing us with insights into their lifestyles, forms, colour, diversity and evolutionary relationships. Indeed, our repository is growing faster than we

can assimilate and get used to its implication. It is possible, (though unlikely,) that paradig shifts may one day make our current view o tinct animals as odd and dated as Homo dilu itself.

This is why we prepared this collection - to s you some of our mistakes, and hint at what might be missing on the way. We don't prete to have any conclusive answers - the only so statement we can offer in this work is that n should "rest easy" with the facts on hand. O picture of the past is constantly evolving, an will continue to evolve as new discoveries ch or sweep old certainties away. We hope you enjoyed your ride with us through All Yester and All Todays.

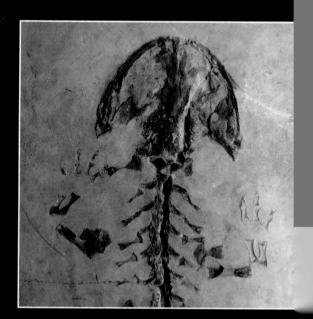